DRAYTON HALL

THE CREATION AND PRESERVATION
OF AN AMERICAN ICON

Drayton Hall Preservation Trust

Published by The History Press
Charleston, SC
www.historypress.net

Copyright © 2018 by Drayton Hall Preservation Trust
All rights reserved

First published 2018

Manufactured in the United States

ISBN 9781467140508

Notice: The information in this book is true and complete to the best of our knowledge. It is offered without guarantee on the part of the author or The History Press. The author and The History Press disclaim all liability in connection with the use of this book.

All rights reserved. No part of this book may be reproduced or transmitted in any form whatsoever without prior written permission from the publisher except in the case of brief quotations embodied in critical articles and reviews.

CONTENTS

Acknowledgements	5
Introduction	7
1. Drayton Hall: A Social History, 1738–1974	9
2. Constructing John Drayton's Palace, 1738–1752	27
3. "Better Laid Out, Better Cultivated": The Eighteenth-Century Landscape of Drayton Hall	33
4. The Design of Drayton Hall	39
5. Preserving an American Treasure	77
Conclusion	89
List of Figures	91

ACKNOWLEDGEMENTS

This book is dedicated to all those who have played a role in Drayton Hall's history and without whose contributions Drayton Hall's survival would not be possible: the Drayton family; the Bowens family and other Africans and African Americans who lived and worked on site during slavery and freedom; the dedicated staff, Board of Trustees and volunteers of the Drayton Hall Preservation Trust; our preservation partners; and the Friends of Drayton Hall, whose continued support ensures Drayton Hall's legacy will enrich generations to come.

Publication of this work was made possible thanks to the generosity of Jill and Richard Almeida and the Friends of Drayton Hall.

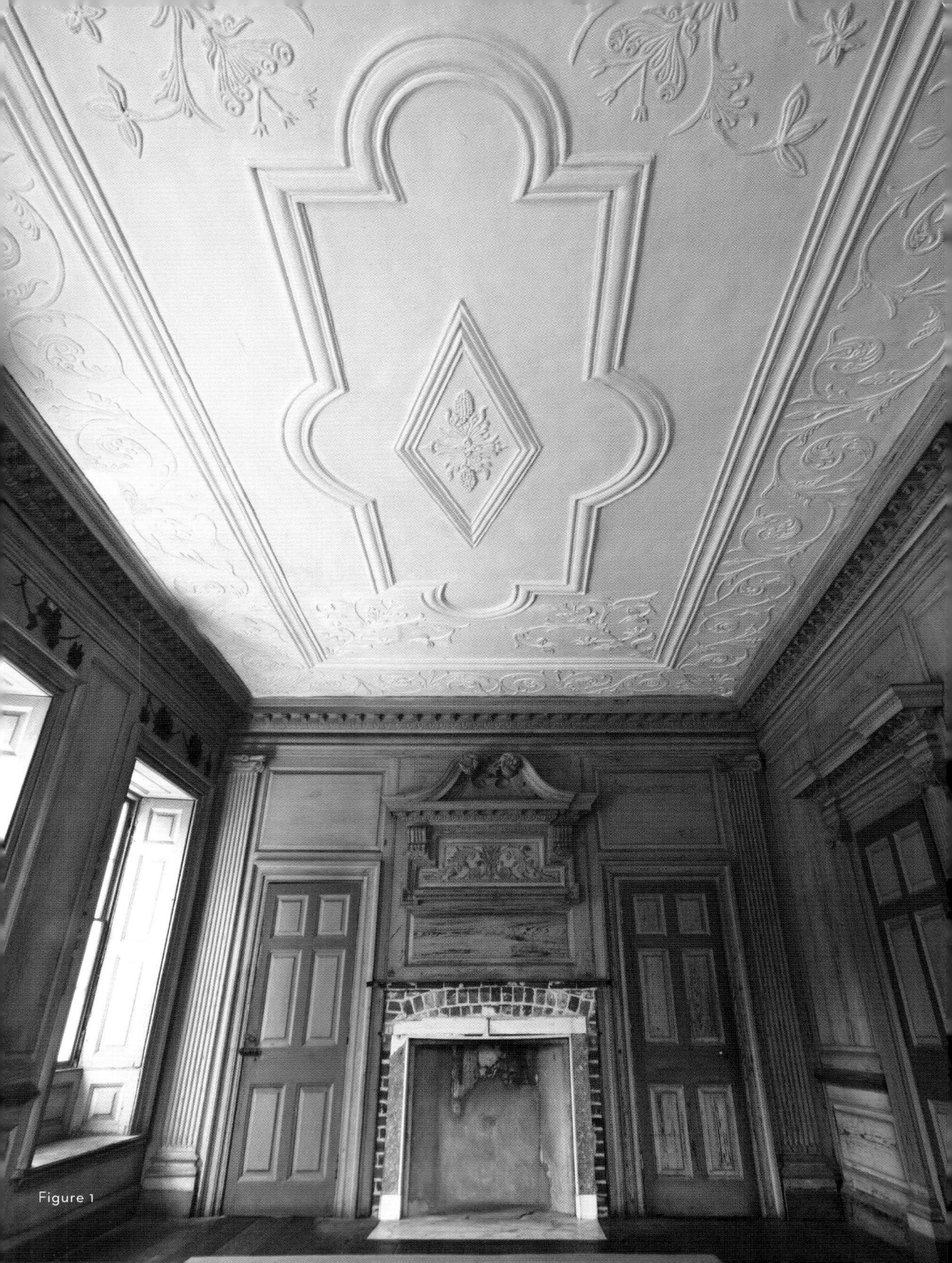

Figure 1

INTRODUCTION

Few undertakings are more exciting and offer greater opportunity for self-expression than the construction of one's house. Imagine, then, the possibilities that must have unfolded before the twenty-three-year-old John Drayton as he established his home seat at Drayton Hall beginning in 1738. Surely he was aware that the choices he would make regarding the design of his house and landscape would be nothing less than a physical manifestation of his wealth, intellect, influence and social aspirations—one that would endure, with any luck, for generations to come.

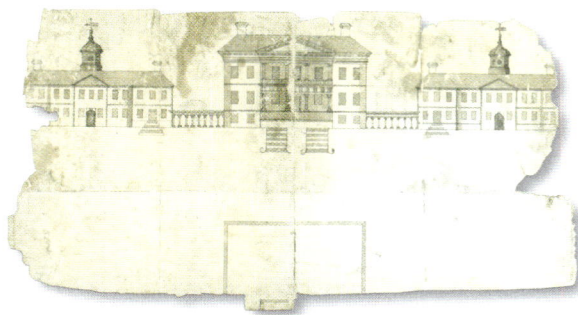

Figure 2

SHORTLY AFTER John and Margaret Glen Drayton, his third wife, took up residence at Drayton Hall with sons William Henry and Charles in the early 1750s, his newly constructed home seat was referenced in the *South Carolina Gazette* as nothing less than a "Palace and Gardens."[1] Drayton Hall was one of the most significant estates assembled in the British colonies, and its rare survival makes the property an icon of American history, design and historic preservation.

1. *"To Be Sold."* South Carolina Gazette, *December 22, 1758.*

INTRODUCTION

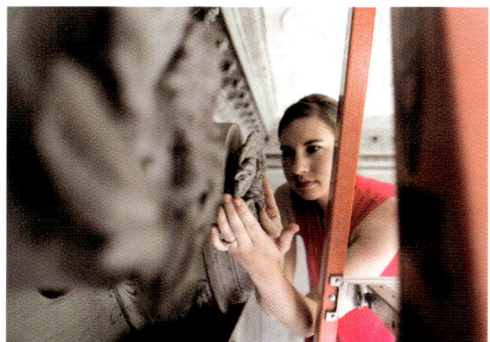

DRAYTON HALL is a rare survivor of a succession of calamitous events that directly or indirectly led to the destruction of many of Charleston's great houses. Why Drayton Hall survived when so many other houses did not is largely a mystery, but its remarkable condition enables us to better understand the man for whom it was built and the society in which he lived. For this reason,

Figure 3

our preservation philosophy is to preserve the house as we received it from the Drayton family rather than restore it to a particular period. Such an approach offers a uniquely authentic experience for visitors and makes it possible to continuously learn from the site's surviving historic resources.

Figure 4

IMAGINE A YOUNG professional building a new house that is so extraordinary, it comes to be known as the first and best of its kind. That is exactly what John Drayton did! In the past, scholars speculated about who John Drayton may have employed to design such a magnificent house, but new research suggests that this mysterious designer never existed; it was the young Drayton himself who was responsible for designing the earliest and finest example of Palladian architecture in colonial America.

CHAPTER 1

DRAYTON HALL

A Social History, 1738–1974

Little is known about John Drayton's life prior to purchasing the tract of land on which he would construct what became known as Drayton Hall. Born into one of South Carolina's leading colonial families to Thomas and Ann Drayton at the family's Magnolia Plantation around 1715,[2] Drayton is virtually absent from the public record until his purchase of the property. It's likely that he traveled abroad and was educated in the United Kingdom prior to 1738, and reasonable guesses can be made about his politics and social life based on what we know of his contemporaries.

Figures 5a & 5b

2. *John Drayton was born between June 12, 1714, and June 5, 1716, according to the dates of his father's will and the codicil to the will recording his birth. Dorothy Gail Griffin, "The Eighteenth Century Draytons of Drayton Hall." PhD dissertation, Emory University, 1985, 12.*

What we know for certain is that throughout his adult life, he steadily advanced his political position within colonial South Carolina. From a humble beginning as a warden for St. Andrew's Parish Church, he became assistant judge for the Justices in the Commission for the Peace in 1756 and ultimately served as a member of His Majesty's Privy Council from 1761 to 1775. Drayton's status also advanced through his marriages. Due to untimely deaths associated with childbirth, John Drayton married four times and fathered a total of nine children, six of whom survived to adulthood.

In addition to his political duties, John Drayton was also a successful planter. Research of surviving land grants and plats has shown that during his lifetime, he owned and operated upward of 76,000 acres of agricultural land stretching between Charles Town to the north and the Satilla River in Georgia to the south, where he raised cattle and pigs for exportation to the Caribbean sugar islands and grew rice and indigo for the European market. When viewed alongside Drayton Hall, which grew from 350 acres to 600 acres during Drayton's lifetime, this empire of commercial holdings makes it apparent that Drayton Hall was conceived to operate as a home seat and display of status rather than a traditional commercial plantation.

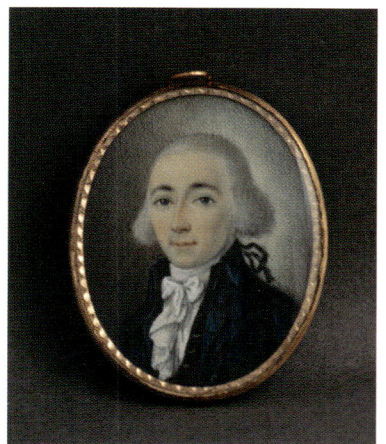 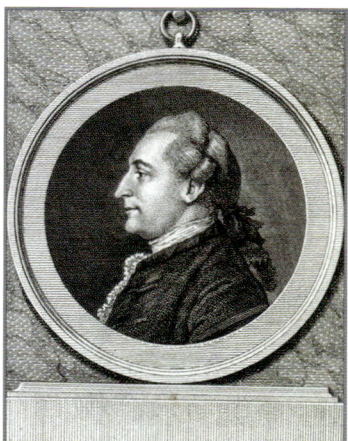

Figure 6 Figure 7

JOHN DRAYTON'S ELDEST SON, William Henry Drayton, departed the South Carolina Lowcountry at the age of eleven for a traditional education in the British Isles. Along with his younger brother Charles, William Henry studied at London's Westminster School, a traditional boarding school where the classics were emphasized. Dancing, fencing and music lessons balanced academic training that focused on Greek and Latin, rhetoric and logic. Charles and his brother then attended and graduated from Balliol College, Oxford.

AT DRAYTON HALL, the ebb and flow of the Revolutionary War meant changes to the plantation system. Crops that had been supported by England or sold to England were either sold elsewhere or given up for staple crops like wheat and corn. Horses became scarce, and many enslaved people found themselves conscripted to work for the armies or took advantage of the chaos to liberate themselves.

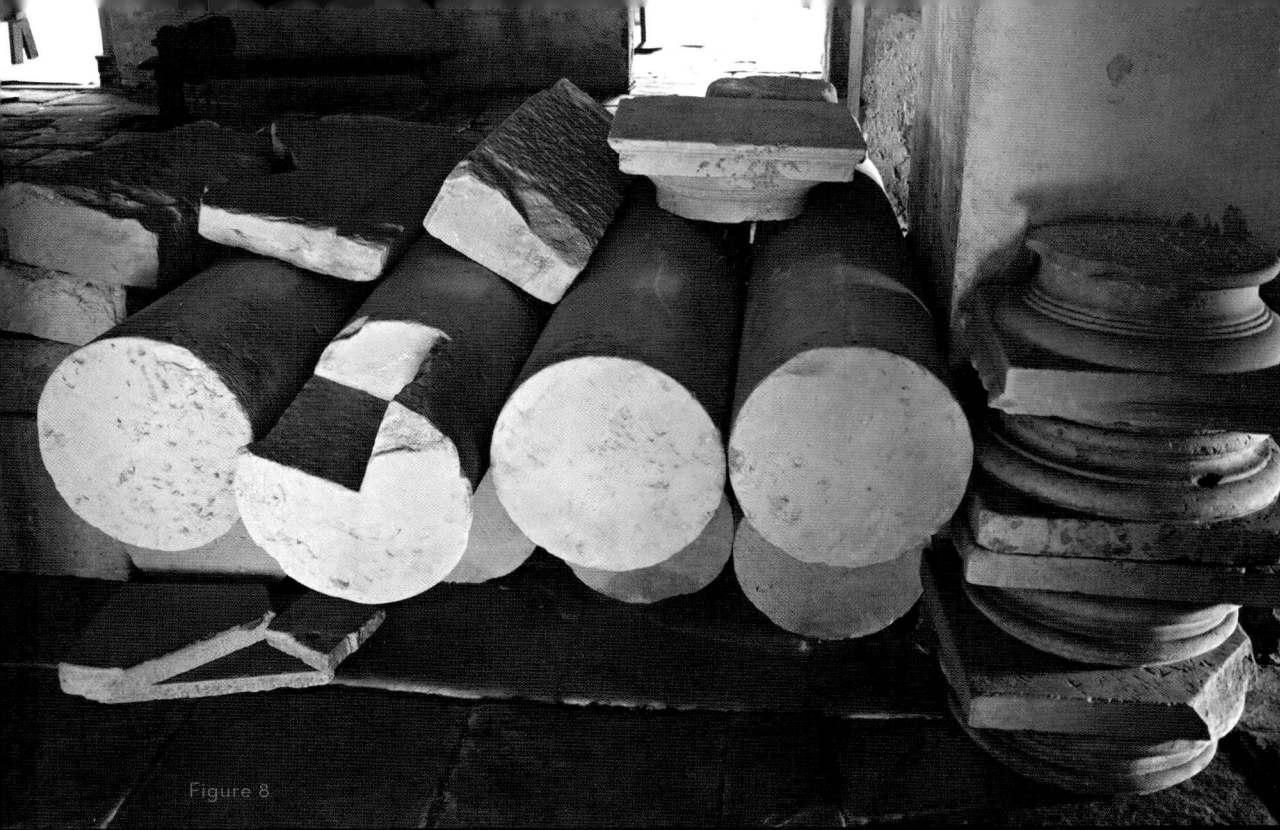
Figure 8

IN 1779, the British army arrived at Drayton Hall. In anticipation of their arrival and the destruction they wrought, John and his family packed what they could and left, not knowing whether they would return. While crossing the west branch of the Cooper River at Strawberry Ferry, John suffered a seizure and died, leaving behind four grown sons from previous marriages, along with his wife, Rebecca, and their three young children.

On March 23, 1780, the British army returned, this time to stay. Drayton Hall became a field headquarters for Sir Henry Clinton, the British commander, and several thousand troops encamped on the grounds. Six days later on March 29, approximately eight thousand British troops crossed the Ashley River at Drayton Hall to lay siege to Charleston. That summer, the house became the headquarters of another British general, Charles Cornwallis.

In 1782, the British gave way to the Americans. General "Mad" Anthony Wayne set up his headquarters at Drayton Hall until the British finally evacuated Charleston just before Christmas. Peace had returned. The house had survived, but its fields, ornamental gardens and many of its buildings would have to be rebuilt.

ALL OF JOHN DRAYTON'S SONS supported the American cause in the Revolution against Britain, but none contributed as much as William Henry. John's firstborn son was appointed to the South Carolina provincial congress, served as its president, issued the state's first order to fire on the British, oversaw the formation of South Carolina's first constitution, served as South Carolina's first chief justice, designed half of the state seal and

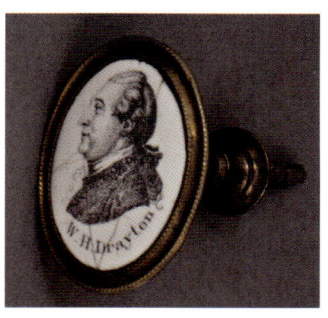

Figure 9

played a role in national politics when he was appointed to be a member of the Second Continental Congress, where he served until his untimely death in 1779 at the age of thirty-seven.

LIKE HIS FATHER, JOHN, Charles Drayton was a product of the Scottish Enlightenment. After an education alongside his older brother William Henry in the United Kingdom, Charles furthered his education by completing a degree in medicine at the University of Edinburgh, Scotland. Upon his return to South Carolina in 1772, Charles continued to practice medicine, marrying Hester Middleton, of Middleton Place, in 1774. The couple went on to have eight children: four sons and four daughters. In 1784, the couple took up residence at Drayton Hall, following the purchase of Drayton Hall from Charles's stepmother Rebecca Perry Drayton. In 1785, Charles began service as lieutenant governor of South Carolina.

DURING HIS TIME ABROAD, Charles had been part of a peer group that included some of the most influential scholars of the Scottish Enlightenment, including Benjamin Rush, Alexander Kuhn and University of Edinburgh professor John Hope. Charles's detailed and almost daily diary entries not only indicate that he maintained correspondence with this peer group following his return to South Carolina but that such exposure had a significant bearing on his intellectual pursuits at Drayton Hall. Indeed, during a trip to the Northeast in 1806, Charles spent significant time conversing and dining with Rush and Kuhn in Philadelphia and nearby Germantown, Pennsylvania.

Figure 10

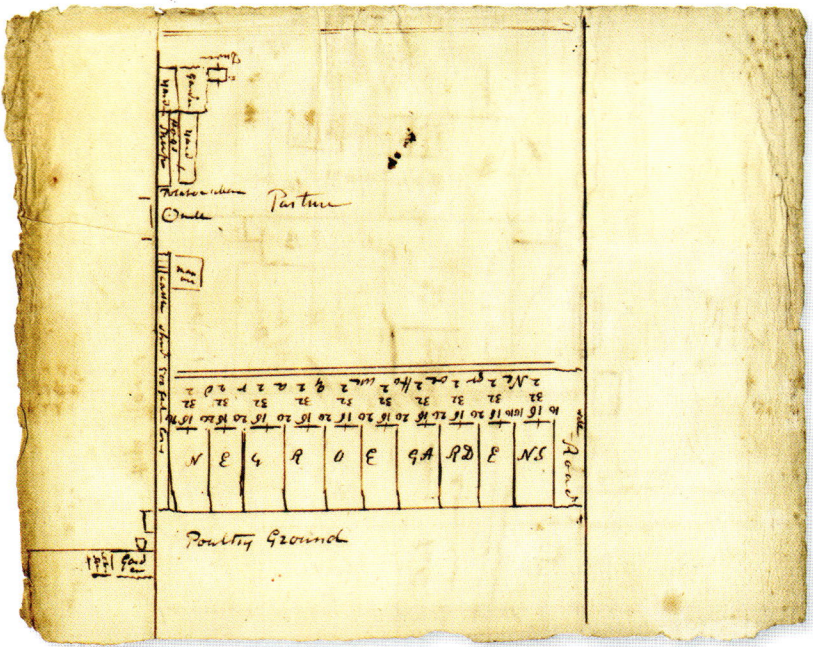

Figure 11

THREE OF CHARLES'S SONS, a daughter and Hester predeceased Charles. Until his death in 1820, Charles shepherded Drayton Hall's main house and associated landscape through a series of modifications influenced by his education and contemporaries. These changes reflected new design innovations and changes in taste as led by the British aristocracy, as well as the possible damages inflicted by years of military occupation.

FROM CHARLES'S WRITINGS, we can see a stratified enslaved society at Drayton Hall through his mention of skilled artisans like blacksmiths, coopers and carpenters. This early nineteenth-century enslaved community lived in "barracks" and houses likely on Drayton Hall's high ground adjacent to the cemetery. Charles noted the construction of these structures sometime around 1804, and future archaeology will be conducted to identify their precise location and living conditions. The duties of slaves during this period are partially noted by Charles Drayton in his diary and include carpenters, gardeners, brick masons, weavers and drivers.

DRAYTON HALL

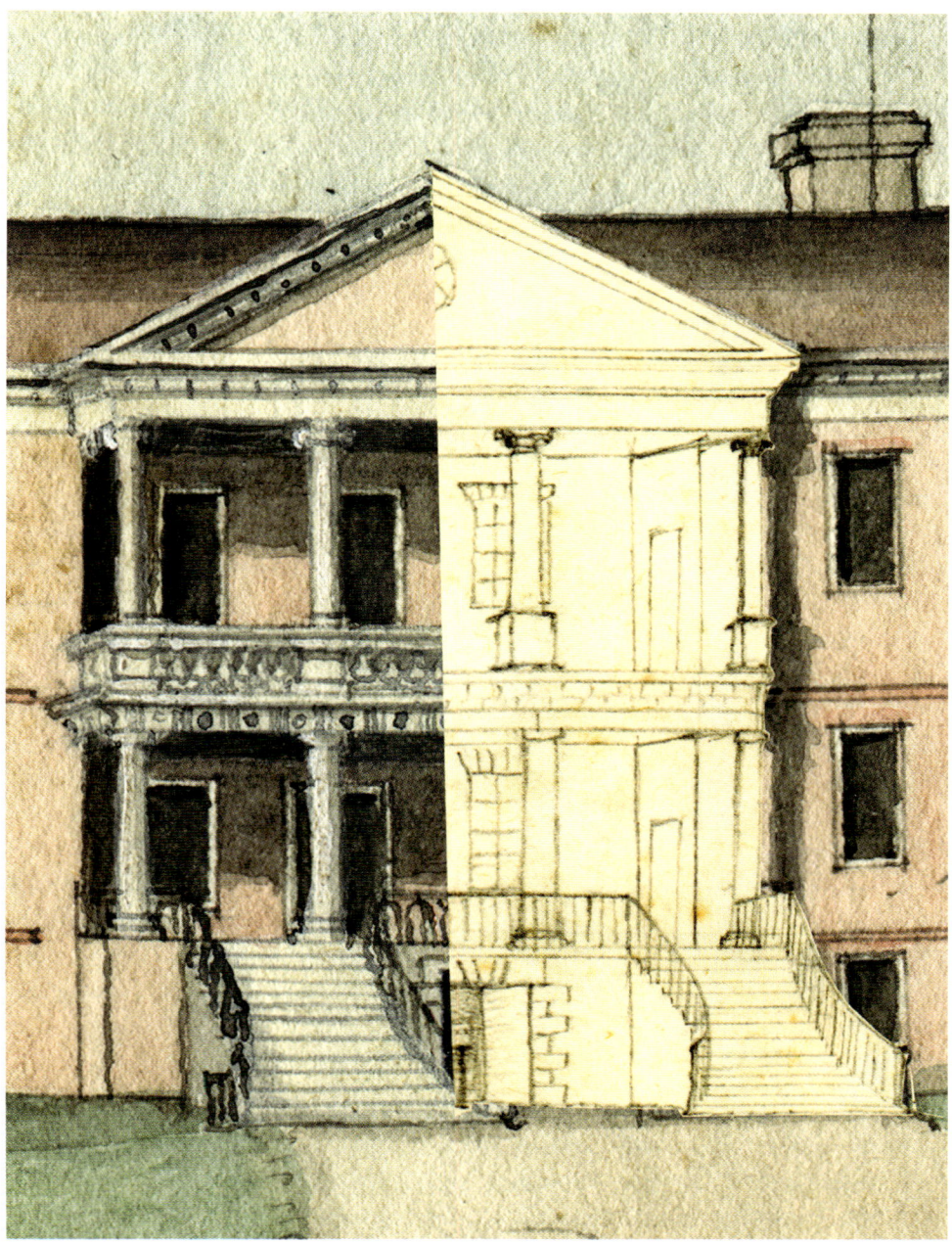

Figure 12

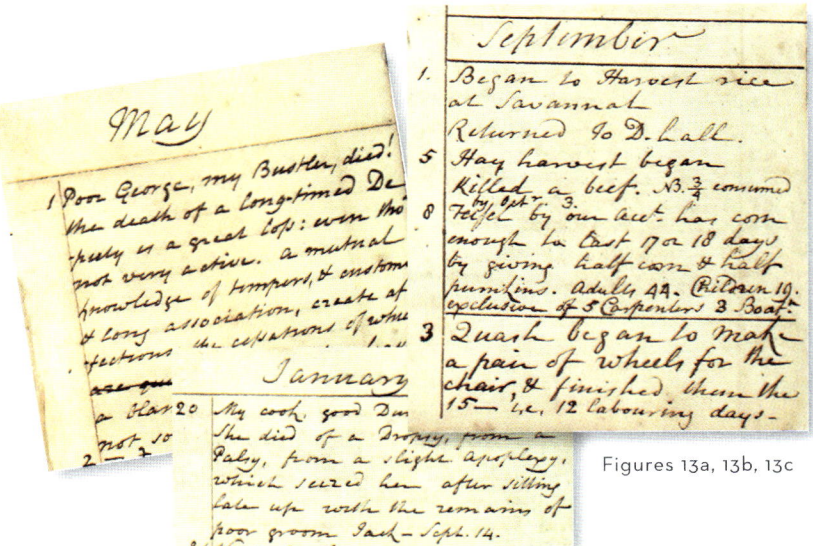

Figures 13a, 13b, 13c

The majority of the entries in Charles's diary referring to enslaved people are brief, often notations about a birth or death. However, some enslaved people are mentioned repeatedly over the course of time. Charles mentions Toby, the carpenter, by name in more than fifteen entries. In his April 2 entry in 1791, Charles wrote, "Sent Toby carpenter to Jehosse with 6 lb of 6d. nails."[3] Jehosse was one of the six or so plantations that Charles Drayton owned and managed. Over the years, Charles noted several other anecdotes about Toby, including the night that Toby narrowly escaped death when he was knocked overboard while on the river. About Dumplin, the cook, he wrote, "My cook, good Dumplin died. She died of a Dropsy, from a Palsy, from a slight Apoplexy, which seized her after sitting late up with the remains of poor groom Jack—Sept. 14."[4]

On August 15, 1785, Charles Drayton wrote about Quash, the carpenter, in his diary: "Quash & Sam came to work at DH."[5] This is the first of many entries about Quash, an enslaved carpenter, who would remain at Drayton Hall until his death in 1811. For twenty-six years, Quash is mentioned regularly, as Charles carefully notes the many tasks being carried out by the carpenter. Quash traveled frequently among several Drayton properties to build and repair buildings and to construct fences.

3. Drayton, Charles, diary, April 2, 1791. 1784–1820. Drayton Papers Collection (NT 91.24).

4. Ibid., September 14, 1801.

5. Ibid., August 15, 1785.

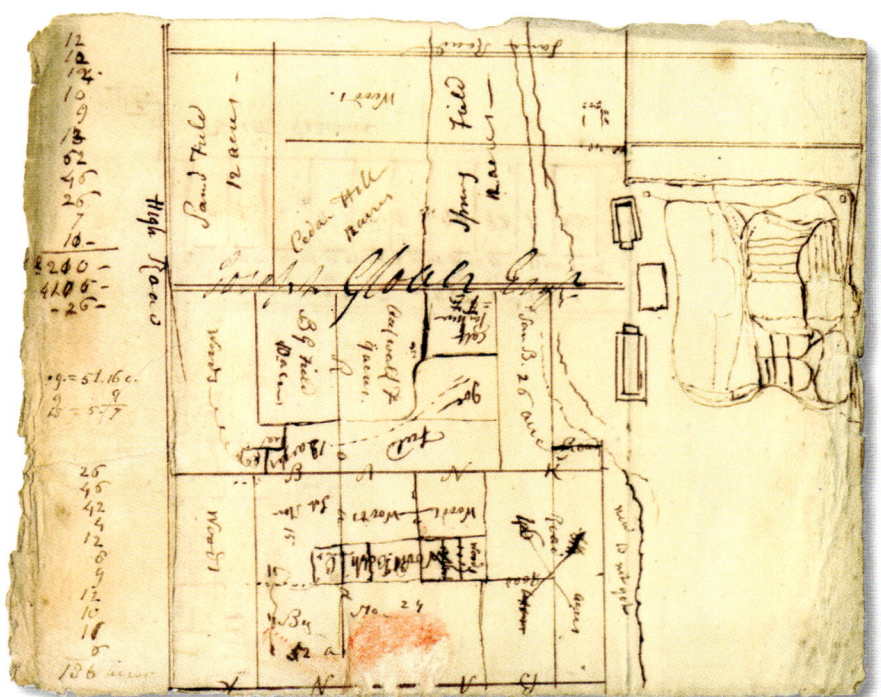

Figure 14

THESE ARE JUST A FEW of many examples of the ongoing maintenance and construction of landscape features tended to by Charles Drayton's enslaved workforce, including gardeners Emanuel, July, Carolina, Exeter and Prince, who worked in the garden and cared for the great lawn leading down to an ornamental pond, which Charles used as a piscatory. As early as May 1793, Charles Drayton wrote in his plantation diary an inventory of garden hoes bought the year before for his enslaved gardeners, including one named Emanuel, who would continue to be included in the diaries through 1812. Emanuel and the other gardener, July, and several junior assistants seemed to be at times in dispute with the overseer, McLeod, and on one occasion they ran away for a month in January 1794, returning to Drayton Hall by February 5 of that same year. Emanuel's tasks, as indicated by Charles, included planting of a variety of vegetables, trees and flowers and overseeding the lawns with oats and mowing them when ready for harvest or to keep a certain aesthetic appearance. A 1790s map marks the burial grounds of the African American cemetery—the oldest documented African American cemetery in the nation.

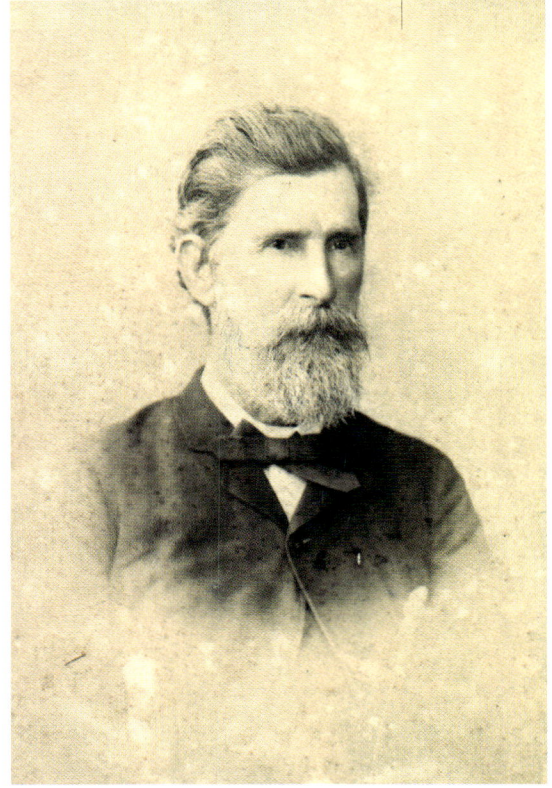

Figure 15

By the outbreak of the Civil War in 1861, Drayton Hall was in the possession of three brothers—James, Dr. John and Thomas—who fervently supported the Confederate cause. James and Thomas joined the Confederate army, while Dr. John contracted with the army as a private physician, caring for slaves who had been leased by their masters to build earthworks.

FOLLOWING THE WAR, in order to make a legal claim on his property in South Carolina, Dr. John Drayton had to pledge to support, defend and protect the Union by signing an Oath of Allegiance, an act he wished to avoid at all costs. Once he signed the Oath of Allegiance, he regained some level of control over the freed people still living on the property. But it was not the same control he had before, and John was distraught over their unwillingness to work under the same conditions as during slavery. The elite white plantation owners expected to exercise the same dominance over African Americans as they had before the war. Because of this change in labor dynamics, Dr. John Drayton and many other planters felt they had no choice but to leave the country to escape the reality of Reconstruction.

Figure 16

In May 1865, he wrote to James: "The Yankey's…object is to trample on us as much as they can."[6] He wrote to Williams Middleton of Middleton Place: "The truth of it is that there are none to be trusted and the quicker we make up our minds to do that and do without them and quit the country if we can, the better for us, if I can possibly raise the money to get me out of it I will but unfortunately there is none here, and you can't get any."[7] By the end of 1865, just six months after returning to Charleston, Dr. John, James and James's wife, Louisa Ann, traveled to Brazoria County in Texas, where Thomas had purchased a cotton plantation before the Civil War. Here James and Thomas died in 1866 as a result of yellow fever, and in 1870, John joined five Texans in buying vast tracts of land in Vera Cruz, Mexico, alongside many former southern elites who were deeply embittered by the situation in the South. Shortly thereafter, Dr. John became U.S. consul in Tuxpan, Mexico, where he remained until his death in 1912.

6. *John Drayton to James Drayton, May 19, 1865, Drayton Family Papers, South Carolina Historical Society.*
7. *John Drayton to Williams Middleton, June 2, 1865, Middleton Papers, Middleton Place.*

DRAYTON HALL

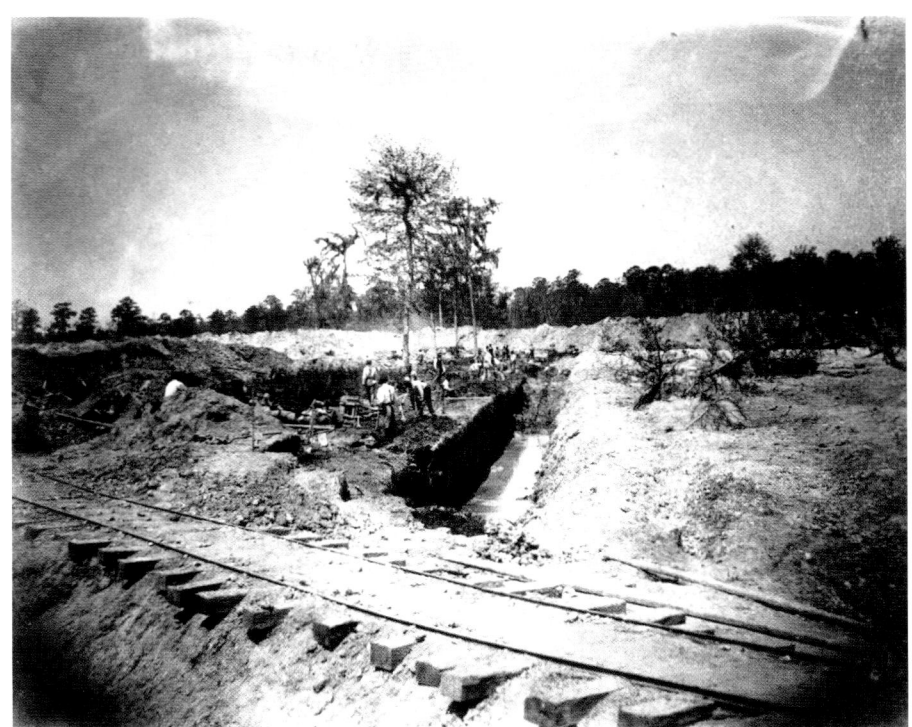

Figure 17a

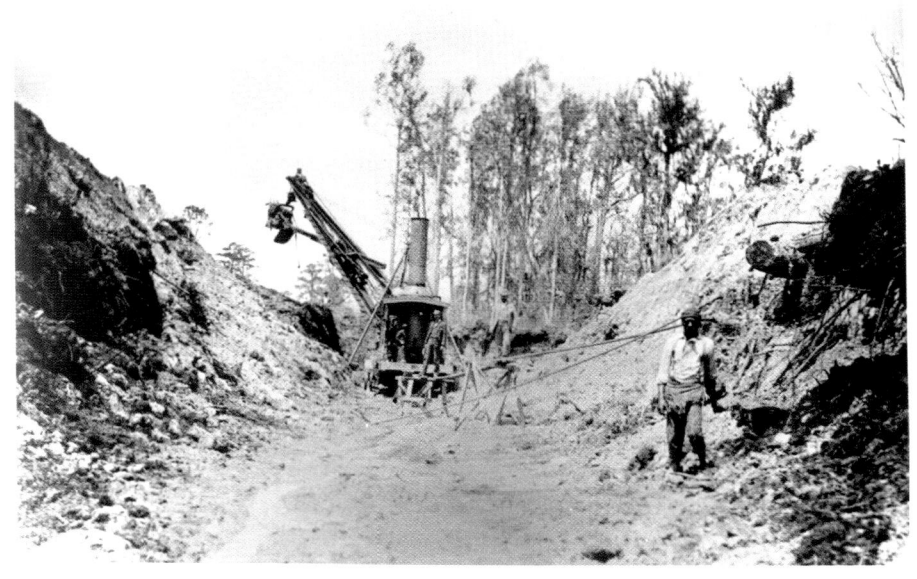

Figure 17b

Following the Civil War, phosphate mining and processing became the primary industry in the Lowcountry. This is vastly different from the sharecropping economy that had previously dominated most of the South. Wealthy landowners could no longer rely on the forced labor of enslaved people, and the reality of this new economic system threatened the power of the white elite. Without enslaved labor, the necessity of fertilizer for the soil was fully realized. Phosphate rock contained elements ideal for fertilizer, and it could be found on the land of former plantations along the rivers of the Lowcountry, including Drayton Hall and other plantations along the Ashley River. The industry transformed the landscape across the Lowcountry. Deep trenches were dug, industrial phosphate complexes were built along the rivers, rail lines were laid and communities of laborers sprang up in the area as people were drawn to the opportunity for work in the mines after the Civil War. Before Dr. John Drayton left the country, he appointed two attorneys as agents of his estate. Beginning in 1866, they leased Drayton Hall to a series of mining companies. Because the African American laborers had more autonomy, mining companies built housing and stores to attract and maintain a labor force.

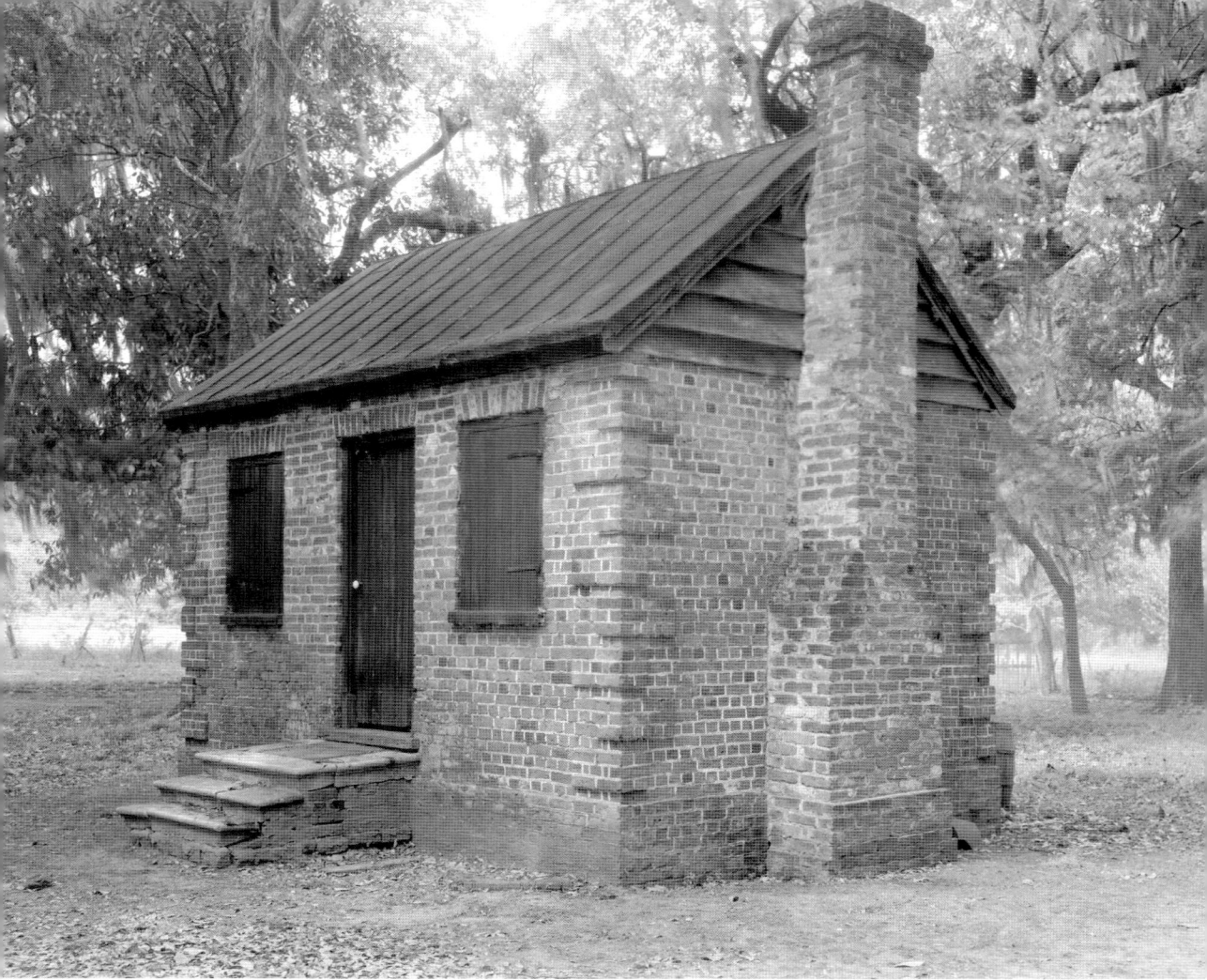

Figure 18

Two stores were built at Drayton Hall, as well as up to twenty houses along MacBeth Road, the entry road, and the river. Miners lived in these houses with their families, paying a monthly rent. At Drayton Hall, the phosphate complex was located next to the Ashley River. According to oral histories, this complex included a barn, washing shed, boiler, machine shop, blacksmith shop, small office and shipping complex. Evidence of some of these buildings exists today. The privy was also converted into an office, and a chimney was added to the east end of it.

THE AFRICAN AMERICAN community that lived at Drayton Hall from 1866 to 1960 developed as a result of phosphate mining. When the industry began, most of the laborers were former slaves who worked on the same land as they had before emancipation. Families lived here for generations—raising children, maintaining their houses and the landscape, cooking, farming, gardening— keeping Drayton Hall alive. As a result, the property was not abandoned, nor did it sit idle. It was home to a thriving community that preserved the property by living there.

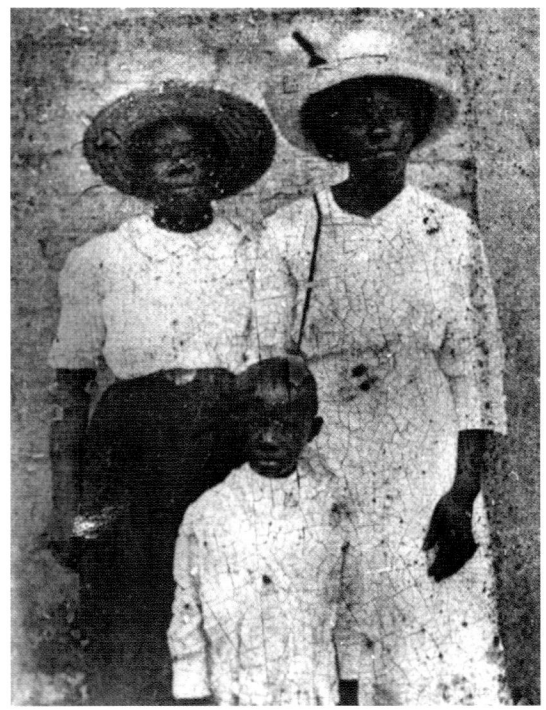
Figure 19

MINING AT DRAYTON HALL stopped by 1910 as the bulk of the industry transferred to Florida, where phosphate was more lucrative to extract. It did continue in the surrounding area on a modest scale until the 1940s, and many people living at Drayton Hall worked in other mines elsewhere after 1910. Aside from mining, farming was the other largest industry in the area. Many people worked at Magnolia Gardens as gardeners. After mining ended at Drayton Hall, the Draytons hired some people to work in the main house, in the gardens and to care for the livestock. Initially, people living at Drayton Hall paid rent to live in the houses, but over time, many of them purchased their homes. By World War II, most members of the community at Drayton Hall had moved away as job opportunities dwindled in the area.

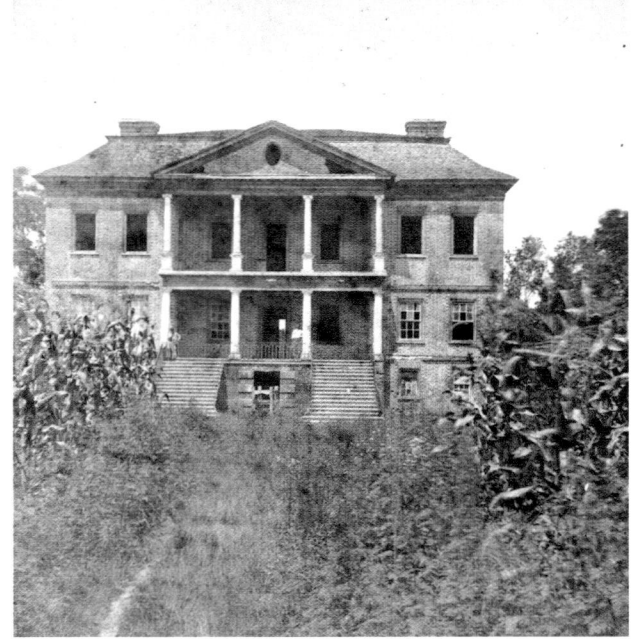

Figure 20a

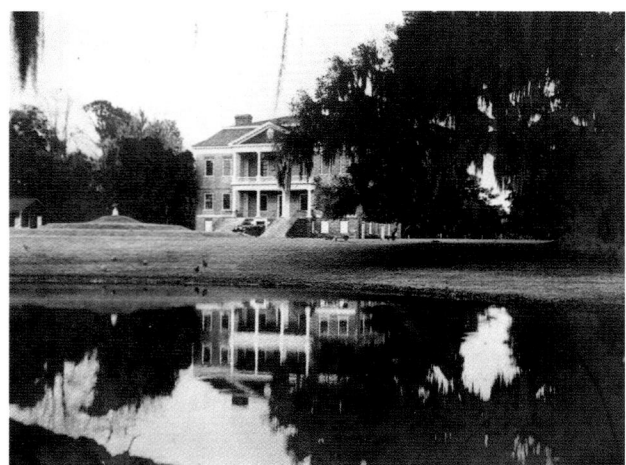

Figure 20b

WITH THE MONEY THE DRAYTONS MADE from leasing out their property for phosphate mining, they made much-needed repairs to the house and aesthetic changes to the landscape to reflect the changing trends. They installed a new roof, replaced the failing brick pediment with wood shingles, put a new plaster ceiling in the Great Hall and painted the interior a new color scheme. On the landscape, they installed a new well, excavated a once small creek near the main drive into a reflecting pond and used the dirt from the pond to construct the three-tiered ornamental garden mound in front of the house. They also built a bridge and an allée of azaleas on the river side of the house, all reflecting the Victorian tastes of the period. While the Draytons paid for all of these changes, they likely hired members of the African American community on the property to do the work. This work was pivotal to preserving the house and landscape throughout the twentieth century, and all of these changes can be seen in the main house and on the landscape today.

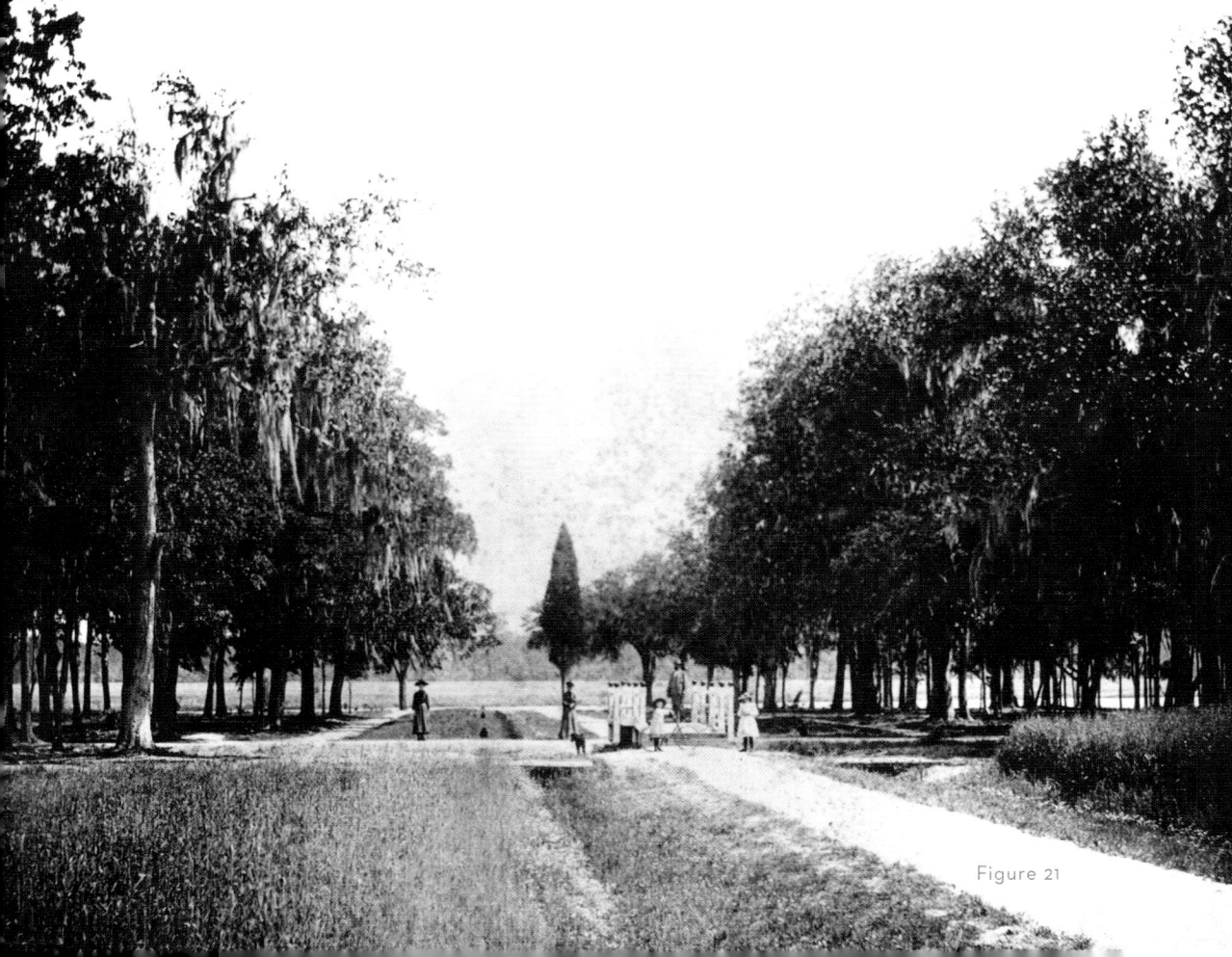

Figure 21

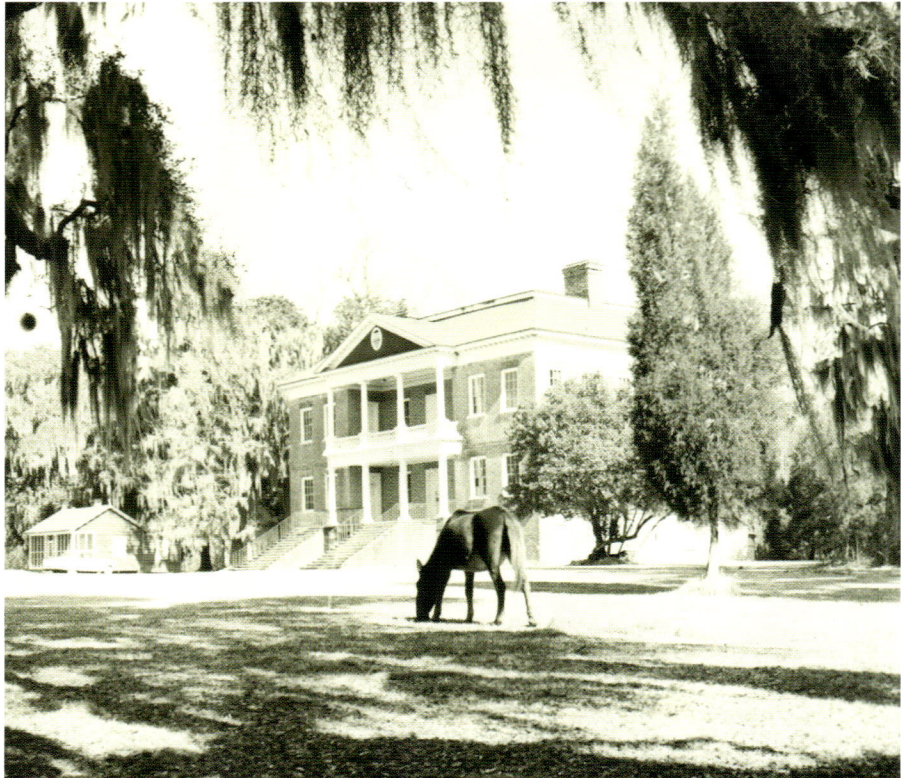

Figure 22

A CARETAKER WAS HIRED from the beginning of the mining endeavor to care for the main house and grounds while phosphate was mined on the property. Until 1960, a caretaker lived in the caretaker's house next to the main house, protecting the property from vandalism and theft. In that one hundred years, the house was never damaged or burglarized. In the absence of a caretaker, however, the house was looted several times, resulting in several architectural fragments and pieces of furniture being stolen or damaged after 1960.

The legacy of the family, their contemporaries and the enslaved inhabitants of the plantation survive today in the home, its landscape and museum collections. Drayton Hall passed through seven generations of family ownership before being transferred to the National Trust for Historic Preservation in 1974. Today, the site—a National Historic Landmark—is operated by the Drayton Hall Preservation Trust.

CHAPTER 2

CONSTRUCTING JOHN DRAYTON'S PALACE

1738–1752

In 1738, the property that would become Drayton Hall was advertised in the *South Carolina Gazette* and described as a "plantation on Ashley River, 12 miles from Charlestown by water." The land is described as 350 acres, 150 of which had not yet been cleared but that included "a very good orchard."[8]

Figure 23

As the third son of Thomas and Ann Drayton, John would not inherit his family's home seat, at present-day Magnolia Plantation, so instead he purchased the land directly south, founding his own estate with his third wife and their two children.

8. *"To Be Sold."* South Carolina Gazette, *December 15, 1737.*

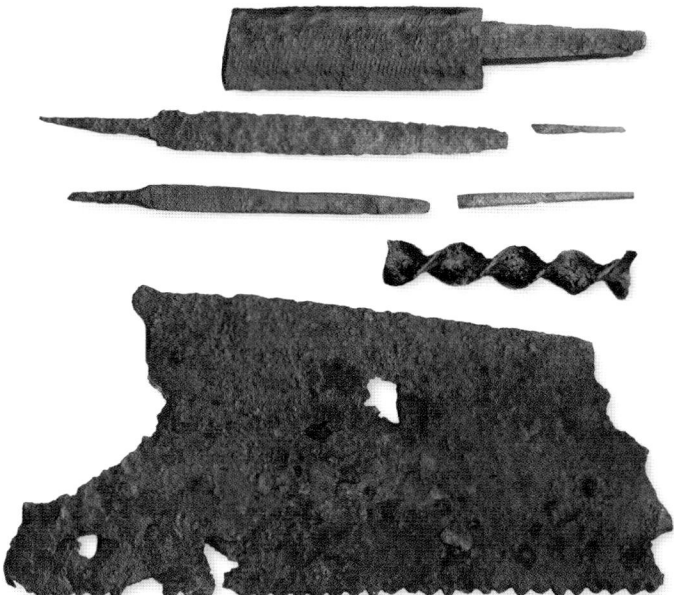

Figure 24

Archaeological evidence indicates that construction of the main house began shortly after the property sale, with work done by a combination of both trained and untrained craftsmen, including enslaved Africans and artisans from Europe.

Approximately 360,000 bricks were utilized in the construction. It is probable that the majority of Drayton Hall's bricks were created from local clay and possibly material extracted from the ponds found to the west of the main house and flanking the entrance road. Such ponds were initially created from a natural watercourse for the purpose of cultivating rice in the late seventeenth and/or early eighteenth centuries—well ahead of Drayton's purchase of the property. After clay for each brick was formed in a wooden mold, it was left to harden in the sun before being fired in a clamp or kiln. Bricklayers using lime mortar then erected the walls of Drayton Hall by placing well-fired bricks in an alternating pattern of exposed "headers" and "stretchers" known as Flemish bond. This aesthetic was interrupted by the use of softer bricks that were rubbed-and-gauged to uniform shapes and colors and used to accent decorative window and door openings, as well as the water tables and belt courses.

Figure 25a

Figure 25b

DRAYTON HALL

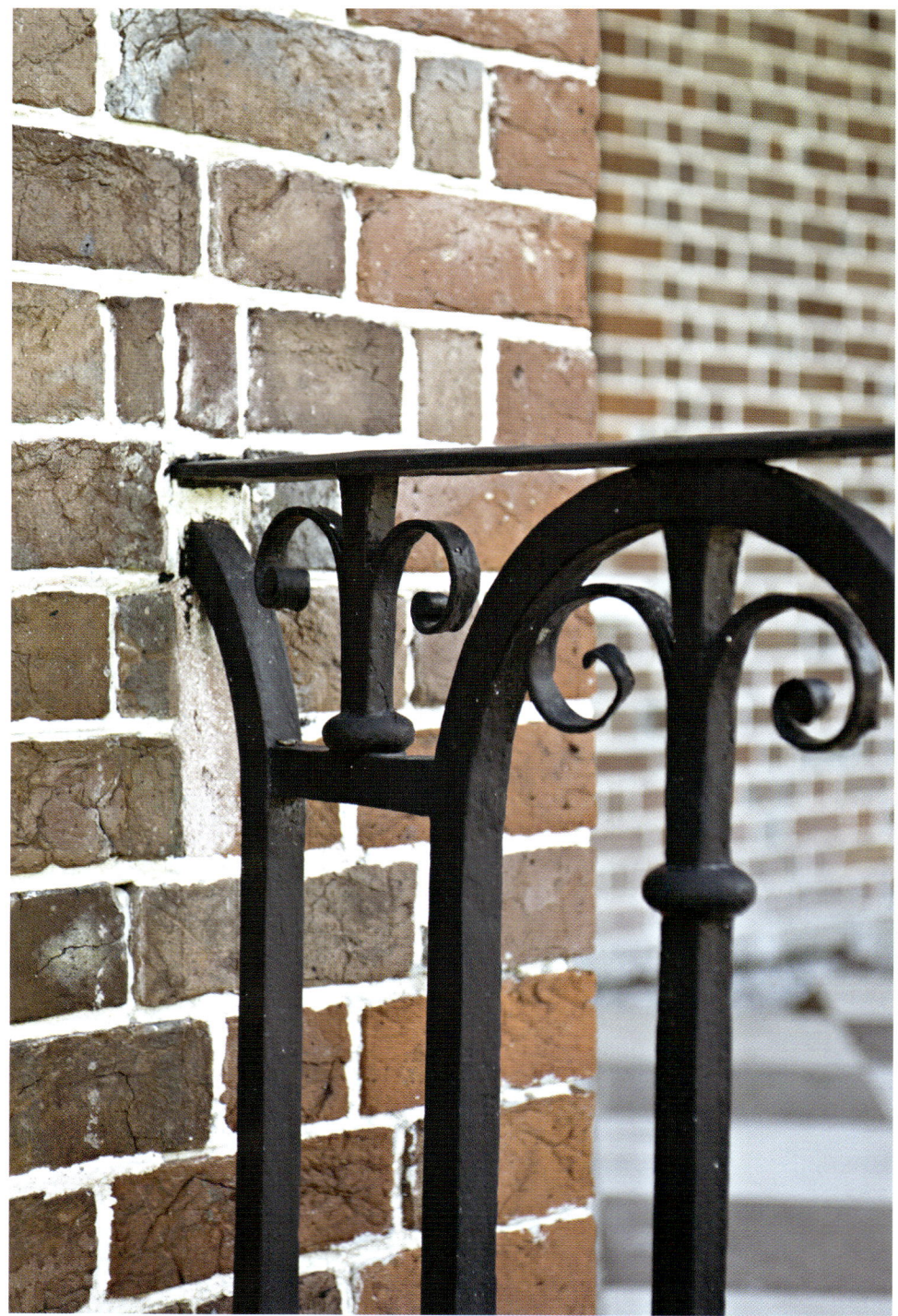

Figure 26

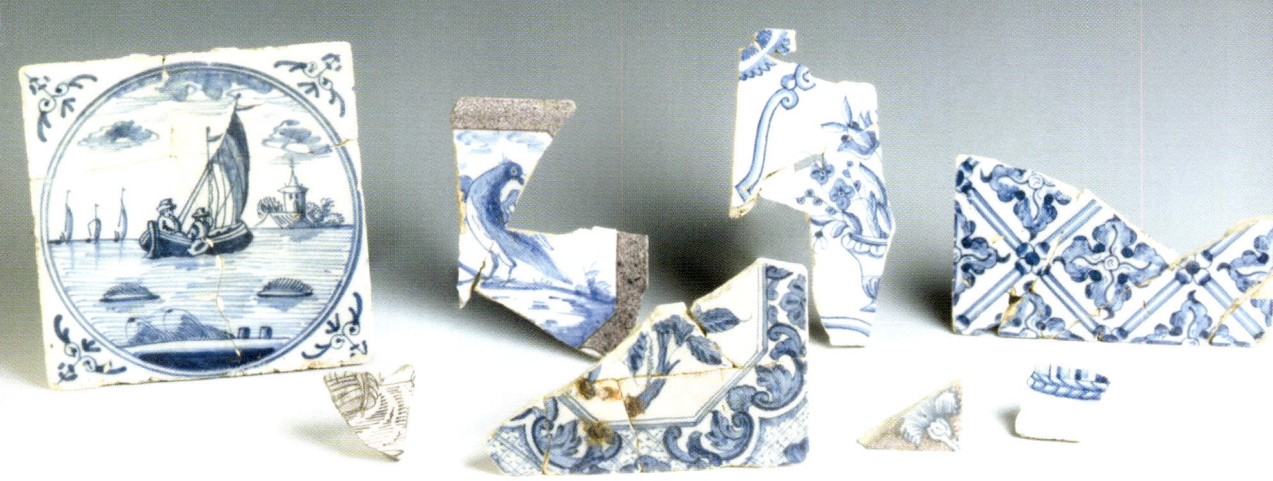

Figure 27b

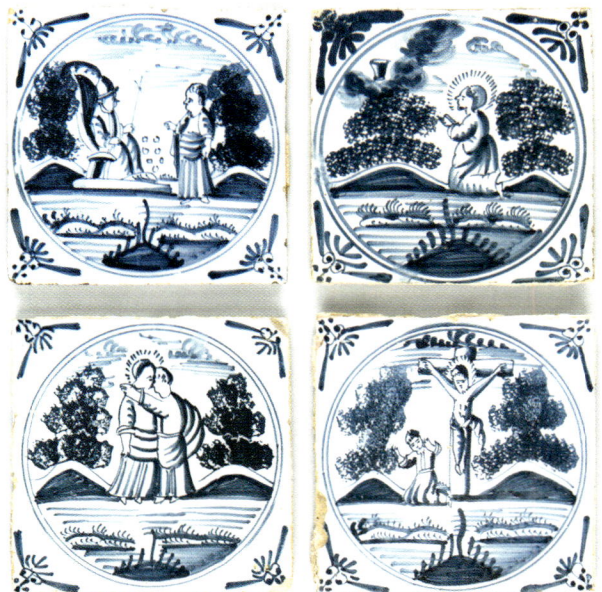

Figure 27a

TIN-GLAZED EARTHENWARE TILES were used to protect and ornament the ten fireboxes found on Drayton Hall's two upper floors. Eight patterns have been identified archaeologically with a further set of forty-eight tiles depicting biblical motifs surviving in Drayton Hall's museum collection. This type of ceramic, known as delft, was produced in London and the Netherlands in the eighteenth century.

DRAYTON HALL'S PORTICO LANDING, river landing and associated stairs are accented with decorative iron railings that were likely imported from England. The balusters were created from square sections of iron shaped to form an arch and connected using small iron bars with delicate iron scrolls as accent details.

DRAYTON HALL

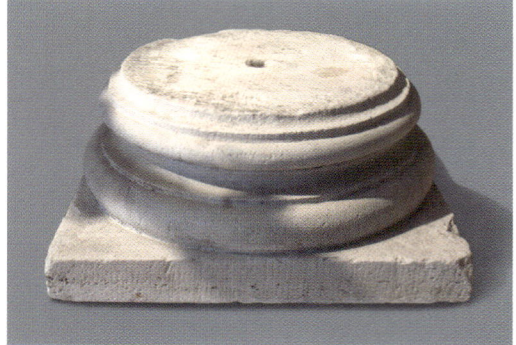

Figure 28

This column base from the first floor of Drayton Hall's double portico was removed, along with associated columns and capitals, during a repair campaign carried out by Charles Drayton in the 1810s. Such work may have been due to damages resulting from the Revolutionary War, as Drayton Hall served as an encampment for British soldiers beginning on March 23, 1780, prior to their attack on Charleston. Created from limestone imported from England, Drayton Hall's portico and this column base represent how John Drayton spared no expense to create a structure that was extremely progressive for its period yet in keeping with the classical architectural vocabulary popularized by Andrea Palladio.

Drayton Hall's mahogany stair brackets exhibit a degree of craftsmanship above and beyond what was typical in the British colonies and more in keeping with examples created in the United Kingdom, signifying the role that experienced European artisans played in the construction of Drayton Hall. In addition to mahogany, local cypress, yellow poplar and long-leaf pine were used in construction.

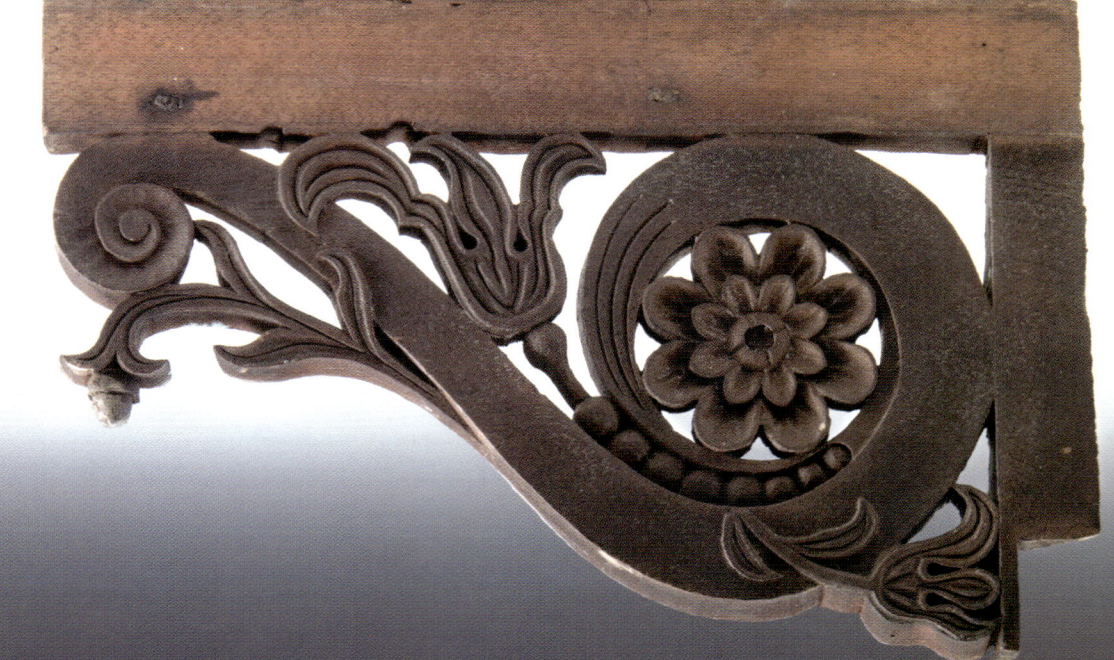

Figure 29

CHAPTER 3

"BETTER LAID OUT, BETTER CULTIVATED"

*The Eighteenth-Century
Landscape of Drayton Hall*

Many eighteenth-century country estates in the British Isles were designed with a picturesque landscape to complement the main house, and Drayton Hall represents a North American extension of this practice. Archival materials and surviving landscape features indicate that the primary façade of the house was fronted with a grand lawn of six acres with views extending to native trees, shrubs and a series of decorative lakes that were previously used for cultivating rice before Drayton's arrival. Between the house and the Ashley River were a number of winding paths that stretched between sculpted terraces, a bowling green, the garden house, water features and ornamental plantings.

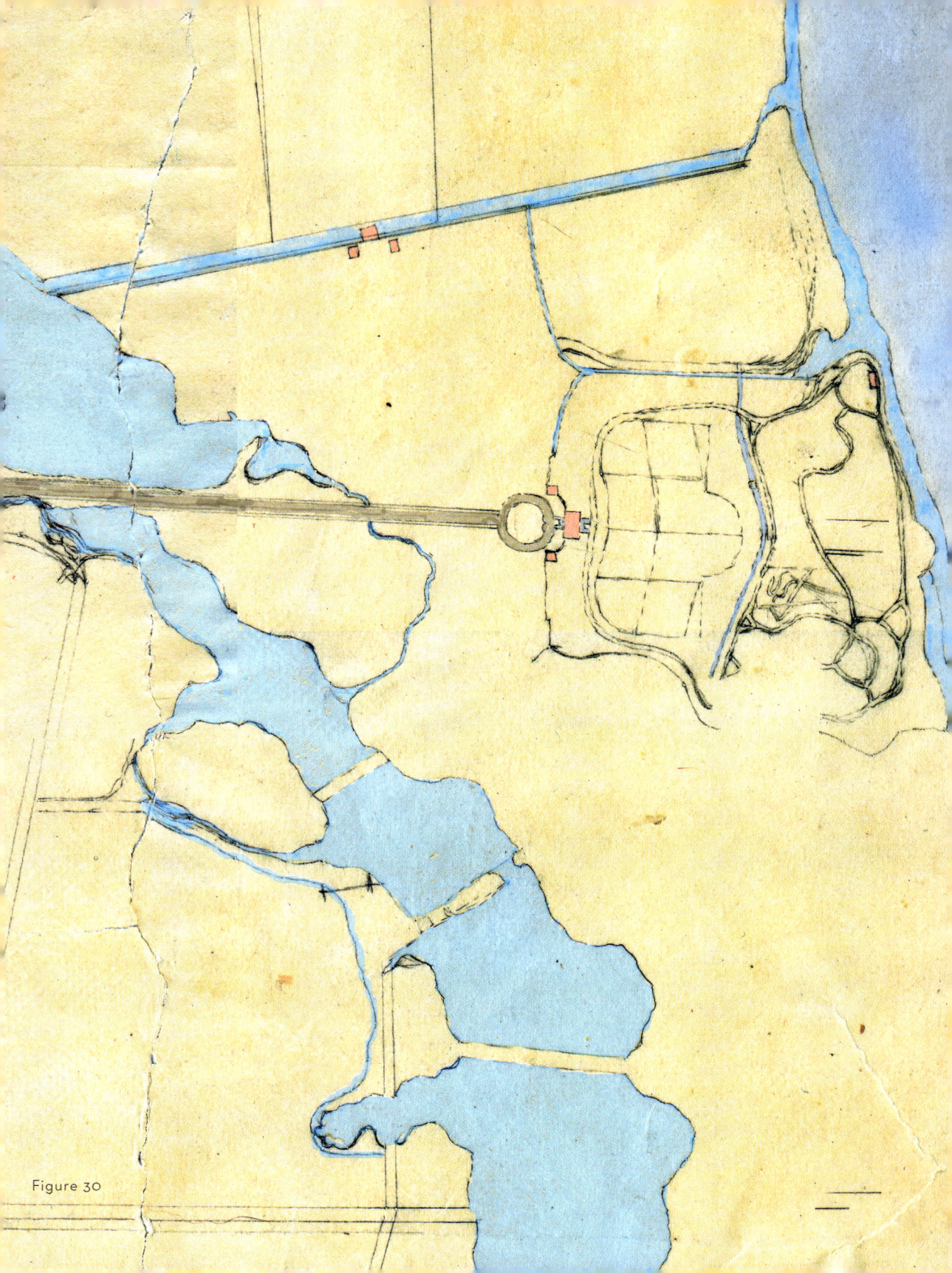
Figure 30

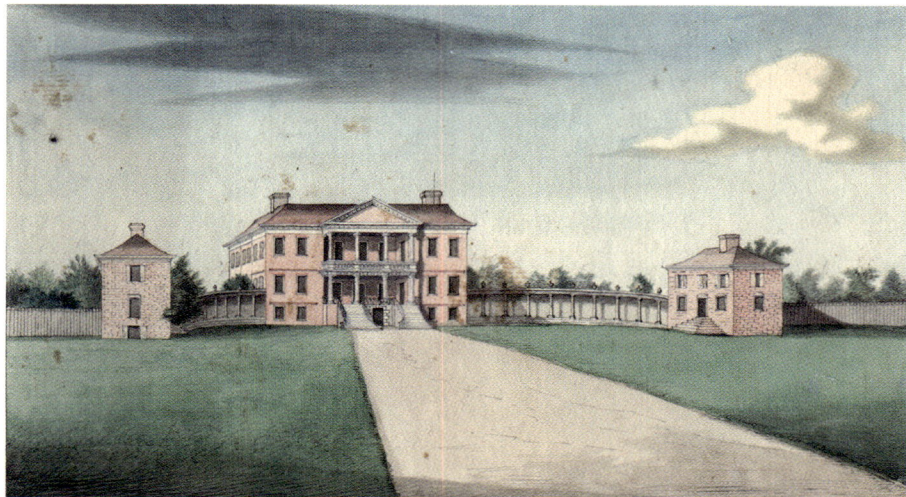
Figure 31

John Drayton left few notes describing the gardens he created to surround Drayton Hall; however, glimpses of this relationship between architecture and landscape can be found in a variety of surviving archival resources, foremost of which is a watercolor of Drayton Hall painted by Pierre Eugene du Simitiere in 1765. The main house, colonnades and flanker buildings are central but surrounded by a verdant lawn with expansive views penetrated by a linear entrance road leading to the portico.

Significantly, a number of trees and botanical specimens appear concentrated in the riverfront garden between the main house and the Ashley River and were shielded from view by a fence or palisade. This configuration indicates that the gardens were only exposed to Drayton's social peers after passing through the house.

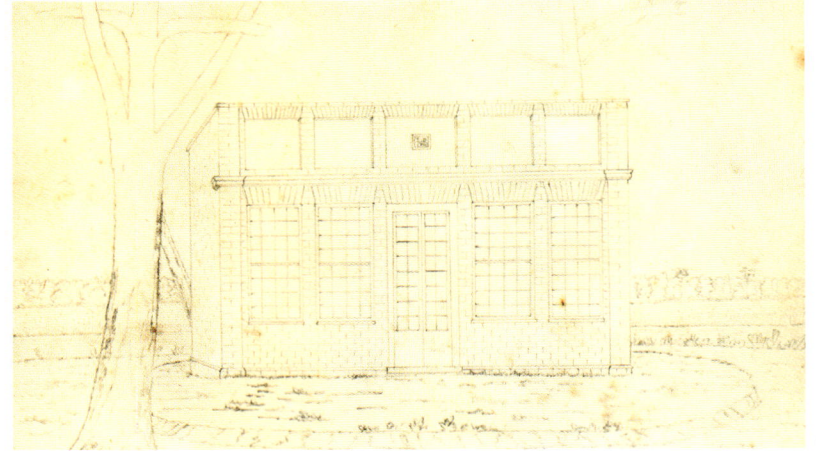

Figure 32a

Figure 32b

AN IMPORTANT FEATURE within Drayton Hall's picturesque landscape was the garden house. Sketched in 1845 by Lewis Reeve Gibbes, the garden house was created from ornamental brick atop a modest man-made earthen terrace and accented above the doorway with a brick cartouche containing the initials of John Drayton and the 1747 date of construction. Archaeological and archival evidence supports this date and indicates that the building was intended to face and receive visitors from the main house. The principal façade of the structure was composed of decorative Flemish bond brickwork with flanking pilasters of rubbed and gauged brickwork and large glass windows and doors. Evidence of wine bottles, eating utensils and tobacco pipes was archaeologically recovered from the inside of this structure, suggesting a social function within Drayton's ornamental gardens. An additional use could have taken the form of a rooftop viewing platform, which was popular in English gardens of the period and would have offered a vantage point over the entire garden.

Figure 33a

Figure 33b

IN ADDITION TO THE GARDEN HOUSE, features of John Drayton's picturesque landscape survive today in the form of terraces and grand native trees. Surviving trees form visible patterns around the estate and were described by Francois Alexander, Duc de la Rochefoucauld-Liancourt, following a visit to Drayton Hall in 1796. The Duc remarked, "The garden is better laid out, better cultivated and stocked with good trees, than any I have hitherto seen," and, "In order to have a fine garden, you have nothing to do but to let the trees remain standing here and there, or in clumps, to plant bushes in front of them, and arrange the trees according to their height." According to the Duc, John Drayton "began to lay out the garden on this principle, and his son, who is passionately fond of country life, has pursued the same plan."[9] What is understood of Drayton Hall's ornamental gardens and landscape design is in keeping with several works in Drayton's library, including *The Gentleman's Recreation: The Art of Gardening Improved* (1717), by J. Laurence (1668–1732).

Another description, noted by Captain Johann Ewald during the encampment of 1780, describes Drayton Hall's landscape as containing a zoological garden, indicating that John Drayton collected and maintained an assemblage of wildlife.[10]

9. François-Alexandre-Frédéric, duc de La Rochefoucauld-Liancourt, *Travels Through the United States of North-America: The Country of the Iroquois, and Upper Canada in the Years 1795, 1796, and 1797, with an Authentic Account of Lower Canada*, vol. 1 (London, 1799), 591.

10. J. Tustin, *Diary of the American War: A Hessian Journal* (New Haven, CT: Yale University Press, 1979), 211.

CHAPTER 4

THE DESIGN OF DRAYTON HALL

More than a decade after work was begun, the house was finally completed. Thanks to recent investigations using the technique of dendrochronology, or tree-ring dating, we can tell that the timbers used to frame the attic were felled in the winter of 1747–48. Taking into account the length of time needed to cure the wood and complete subsequent construction processes carried out by plasterers, joiners, carpenters and painters, it is likely that the house was not inhabited by the Drayton family until the first years of the 1750s. John Drayton's marriage to Scottish-born Margaret Glen occurred in 1752, and this may coincide with the date the family took up residence.

Figure 34

Figure 35

AT THE CENTER OF DRAYTON'S HOME seat was the main house, its colonnades and associated flanker buildings. Constructed in the form of a five-part plan, this richly ornamented complex was influenced by the classically inspired designs of Andrea Palladio that were put forth in the sixteenth century and popularized in the British Isles from the early eighteenth century through the use of architectural books. Surviving evidence of Drayton's library indicates that a variety of these books was once housed in Drayton Hall and likely served as inspiration for its design and construction. With its construction, the house represented the first fully executed example of Palladian architecture in North America.

Assuming the role of gentleman architect was not uncommon for wealthy men of John's time. An account written in 1745 describes the construction of Chief Justice Pinckney's residence, for which "the owner set the story-heights and described each room, its appropriate size, parts 'like the wainscot in Capt. Shubrick's house,' 'like Mr. Whitaker's entry,' etc., etc."[11] It's almost certain that John Drayton directed the construction of his house in this manner. In fact, the word "architect" does not appear in Charleston records until 1752, around the time that John would have been moving his family into the completed house. Yet the question remains: if Drayton Hall was the first of its kind in colonial America, to which influences did John look for inspiration?

11. Samuel Lapham, A History of the Practice of Architecture in the State of South Carolina. Part I: South Carolina Chapter of the American Institute of Architects *(n.p., 1938).*

Figure 36

THE ORIGINAL TREBLE or W-shaped roof and decorative plaster ceilings are among numerous elements of the house that appear to be directly related to architectural books listed in a family library inventory created by Charles Drayton. The publication dates of these books establish that they likely belonged to John, and at least one of the books is clearly the design source for another chimneypiece on the first floor. Besides offering additional evidence that John Drayton designed Drayton Hall, this is remarkable because it places John in a very select group of colonists with the intellectual and financial capacity to appreciate and acquire such volumes.

AS THE ACCOUNT describing Chief Justice Pinckney's house indicates, John Drayton may well have been inspired by architectural elements he observed in other great houses, but with no equal in the colonies we may surmise that John spent some of the early years of his adult life in Great Britain. Evidence to this effect is found in the Great Hall, where an overmantel featured in William Kent's *Designs of Inigo Jones* adorns the chimneypiece on the south wall. Kent's book is not among the list of architectural books in the Drayton family library that were presumably consulted in the construction of Drayton Hall, but the design is executed in stone at Houghton Hall, the home of Great Britain's first prime minister, finished in 1735.

Figure 37

Figure 38

Figure 39

John's grasp of neoclassical design principles extended well beyond the main house to the colonnade and flanker buildings, which together created a Palladian five-part plan, and beyond that to a landscape that was intended to be an extension of the main house complex. A linear drive once led straight from the main road to a forecourt at the base of the portico, and the watercolor by Pierre-Eugene Du Simitiere offers a glimpse of the garden that lay hidden behind a palisade, a garden that could only be accessed by passing through the house. One would begin this passage through the house at the base of the portico.

Drayton Hall's iconic portico is the first of its kind in the world, as it has two stories that both project from and recede into the front of the house. Aesthetically, the portico frames the main entrance of the house with an impressive classical loggia that was once adorned with intricately carved Doric details. During punishingly hot South Carolina summers, the portico also functions as a means of cooling the house by creating a shady spot that funnels cooler air into the house. A triangular pediment with Victorian-era fish scale shingles and louvered oculus crowns the two-story structure. Originally, the interior space of the pediment, called the tympanum, was completely bricked in. Charles added some visual interest and a source of natural light in the attic by installing an oval-shaped glass window, or oculus, in 1791. The portico is supported in part by eight limestone columns, four on each story. Following the classical orders, the columns are Doric on the first floor and Ionic on the second, establishing an important visual hierarchy. The columns on the first floor are all replacements made by Charles Drayton in 1815. He explains in his diary that it took twenty-six men using pulleys and ropes to take down one column.[12] Although Charles only writes about the removal of one column, all of the first-floor columns feature tool marks consistent with nineteenth-century stone masonry rather than eighteenth-century, and a pile of stone columns in the basement of Drayton hall, when reassembled, makes four complete columns.

12. *Drayton, diary, May 2, 1815.*

Figure 40

Figure 41

The steps, like the columns, are cut from limestone, most likely imported from England, and the paving stones that form the checkerboard pattern on the first floor are a combination of early—if not original—limestone and red sandstone mixed with twentieth-century replacements. The wrought-iron hand rails are also composed of original sections joined to later repairs. The thirteenth picket on the right side of the stairs bears the mark "HG," which is believed to be made by Henry Whitney Gardner, an iron worker who is known to have worked in Charleston between 1816 and 1822, roughly corresponding with Charles Drayton's portico repair campaign.

Figure 42

Three doors open off the first-floor portico, but the primary entrance is through the central door into the Great Hall. This room is also ornamented in the Doric order with a decorated frieze featuring triglyphs and metopes that resemble lotus and thistle blossoms. The ceilings on this floor are twelve feet high, and the ceiling in the Great Hall is decorated with cast plaster elements—a design that likely dates to the 1880s. Evidence indicates that the current ceiling is the third to be featured in this space. A sketch by Lewis Gibbes depicts the second ceiling, which was installed in 1818. The design of the first ceiling remains a mystery, although this was likely to be in keeping with the hand-carved ceiling found in the drawing room. The south wall in this room features a large chimneypiece, the overmantel of which is directly related to William Kent's designs of Inigo Jones. The large firebox below retains its original shape but would have originally been adorned with delft tiles.

Figure 43

Figure 44

Figure 45

DRAYTON HALL

Figure 46

Figure 47

Following the progression of the orders, the next room is the Drawing Room. Accessed through a door in the southeast corner of the Great Hall, the Drawing Room was literally a place to withdraw for more private conversations, music or games. The more elaborate entablature and scrolled capitals indicate that this room is of the Ionic order and, thus, a more important space. Such cues may be lost on us today, but people of John's time would have understood the significance of being invited into such a room. The ceiling in this room is an elaborately carved plaster ceiling that is original to the house. To help ensure its preservation, tours do not enter the room above it, known as the Upper Drawing Room, keeping damaging vibrations to a minimum. Two doorways were constructed on the north wall, although one doorway is completely bricked in. This original load-bearing brick wall was once covered by a door that was constructed with the sole purpose of maintaining balance and symmetry in the room. Both doors were once topped by triangular open pediments, which were removed at an unknown point in the house's history. Only their "ghosts" remain in the paint on the wall.

Figure 48

Figure 49

Paint tells another interesting story on the west wall of the room, where the missing mantel and firebox surround reveal a section of original wall paint dating to John Drayton's time. While many of the walls in the house are painted a blue-green color dating to the 1880s, a new composition mantel installed in the room by Thomas Walker for Charles Drayton in 1802 covered an original section of paint that was not revealed and therefore not painted green in the 1880s. It wasn't until the mantel was removed in the mid-twentieth century that this paint, a tan or yellow ochre color, was exposed once again. The design of the new mantel, while not in keeping with the original Georgian details, was fashionable at the turn of the nineteenth century when Charles had this and two additional mantels installed on the first floor of the house. Above the windows in this room, beautiful carved mahogany swags add yet another layer of ornament that can be dated to the first period of the house.

Figure 50

Figure 51

Figure 52

Figure 53

A SMALL PASSAGEWAY in the west wall leads from the Drawing Room into what is referred to today as the Growth Chart Room. Flanking either side of the door to the portico is a family growth chart that dates back to the late nineteenth century. The value of our preservation philosophy is readily apparent in this room, as so many layers of history are represented within these four walls. On the east wall, a Georgian overmantel dating to John's time is visually supported by a much more delicate Federal-era compo mantel dating to Charles's occupation. The Rumford firebox, a trapezoidal opening that improved the projection of heat into the room, can also be dated to a remodeling campaign initiated by Charles in 1804.[13] Until recently, the windows were flanked by louvered shutters dating to the Victorian era, with folding pocket shutters original to the house found just to the outside. Victorian-era porcelain picture knobs remain embedded in the walls, as do the ghosts of the pictures that once hung on them. Finally, raising butt hinges on the doors in this room were a clever way to cause a door to rise slightly as it opened into the room so that it would not get stuck on the carpet.

Figure 54

13. Drayton, Charles, diary, November 12, 1804.

Figure

Figures 56a & 56b

ACROSS THE GREAT HALL from the Growth Chart Room, on the north side of the house, is a room that Charles Drayton labeled as the Library in his diary. Here, we get our first glimpse of the spiral staircase that once traveled the full height of the house from the basement to the attic. Termite damage resulted in the basement portion being removed in the late 1970s, but the staircase remains the only means of accessing the attic from the first and second floors. To the left of the spiral staircase is an original mantel and overmantel that is a direct quotation from Plate 91 of James Gibbs's *A Book of Architecture*, published in 1728. This book was listed among the architectural titles in the Drayton library and would have been used to direct the construction of this chimneypiece.

ANOTHER SMALL PASSAGEWAY leads from the Library to the northeast corner of the house, a room labeled by Charles Drayton as the Dining Room. This seems logical, as the spiral staircase first glimpsed in the last room provided direct access from the basement, where food was prepared, to this rather large space with a handsome chimneypiece. The mantel in this room was among those that Charles Drayton chose to have updated with a compo mantel that still survives in the space. Like the Drawing Room on the opposite side of the house, this room features two doors on its longest interior wall, one that opens into the Great Hall and one that reveals a load-bearing brick wall, once again reinforcing the importance of balance and symmetry throughout the house. Curiously, this area of exposed brick reveals a decorative pattern of glazed headers in a "diaper," or diamond, shape. We can only assume that the brick mason was practicing a decorative technique in an area where a mistake would be hidden from view. This exposed section of wall also reveals how the wood paneling is attached to the wall. A wooden nailing block is laid into the wall and used to attach the paneling to the wall in such a way that it floats on top of the brick.

Figure 57

IN THIS ROOM, it seems especially fitting to contemplate the two vastly different worlds that collided in the house. While the Draytons sat down to elaborate dinners in this room, enslaved men and women would have traversed the dark, narrow spiral staircase carrying food, laundry, chamber pots and the like up and down through this concealed circulation space. Imagine if you will what it was like to navigate such a tight space with a candle in one hand and a heavy or fragile load in the other. Such was the daily experience of the enslaved people who were integral to the kind of comfortable existence to which the early Draytons were accustomed.

DRAYTON HALL

Figure 58

Figure 59

61

Figure 60

THE STAIR HALL is the next stop in the classical progression through the house. Like the Drawing Room, the carved ornament in the Stair Hall is of the Ionic order, a step up from the Doric ornamentation of the Great Hall. This is an impressive space with a ceiling height of twenty-seven feet. Although it is finished with undecorated plaster today, it is likely that an elaborately carved plaster ceiling once adorned this space. Evidence to this effect can be seen in the soffit below the second-floor landing, in which a partial carved plaster ceiling survives. The paneling is currently painted with the 1880s blue-green color seen throughout the house, while the mahogany wainscot is left unpainted. The original paint scheme in this room was much more striking, with yellow-ochre walls and vermillion on the wainscoting. The vermillion paint/stain was also applied to the mahogany balusters, handrails and decorative brackets on the stair ends. Although most of the vermillion has been removed, the staircase is largely composed of original material. The only exceptions are the handrail and balusters below the first landing on either side, which are now machine-turned pine instead of mahogany. The large Victorian-era newel posts at the base of the stairs are also replacements where the handrails once ended with an elegant volute and curtail step.

Figure 61

Figure 62

At the top of the stairs, one enters the most important room in the house, as indicated by the classical orders. The Upper Great Hall is ornamented with Corinthian details that convey the high status of the room and those who are granted access to it. The main focal point of the room is the chimneypiece on the south wall. Both the mantel and overmantel remain unchanged from their original appearance, but no direct pattern book influences have yet to be identified. The firebox is quite large, having remained unchanged when Charles was converting to Rumford fireboxes in the early nineteenth century. It, too, would have been lined with decorative delft tiles. In the center of the overmantel is a large painting on canvas of a Drayton family heraldry element. A banner proclaims the motto, *Hac iter ad astra*, meaning "this, the way to the stars." Such was probably installed in the late nineteenth century, and the original decoration of this space is unknown.

DRAYTON HALL

Figure 63

Figure 64

65

The ceiling is modestly composed of unpainted bead board—a repair made in the 1880s that was necessitated by years of leaking water in the attic. This ceiling was on the front line of a battle that the Draytons waged with their leaking roof for generations. Briefly mentioned before, the original roof was a treble or W-shaped roof. Vastly different from the tall, red metal roof we see today, the original roof had a profile approximately half the height of the current one and was sheathed not in metal but with cypress shingles and later with slate. What appeared to be a simple hipped roof on the exterior was in reality a system of peaks and valleys that funneled rainwater into two internal gutters running the length of the house from north to south. Such a system works tolerably well in climates where rain falls steadily and can be carried off by the downspouts efficiently, but in the temperate climate of coastal South Carolina, with its sudden torrential downpours, the gutters and downspouts are completely overwhelmed by the sudden massive volume of water and begin to overflow inside the house. The diaries of Charles Drayton document his constant attempts to fix the leaking roof. Well after Charles's death, sometime in the last quarter of the nineteenth century, the family finally abandoned all hope for salvaging the treble roof and had a cap placed over the central portion, sealing off the gutters and resulting in the much more visible roof we see today.

While Mother Nature can be blamed for the condition of the ceiling in the Upper Great Hall, the condition of the floor is an issue with man-made origins. Visitors to this room today must stay within a roped-off area in the northernmost third of the room. This portion of the floor has been reinforced in response to structural deficiencies in the floor. Typically, in a timber frame structure like Drayton Hall, large summer beams would run from the east wall to the west wall, splitting the floor space into three ten-foot sections. Joists would then span from north to south in ten-foot sections, supported by the summer beams. However, in the mid-nineteenth century, the summer beams were removed, resulting in floor joists that span a full thirty feet. As you might imagine, this makes the floor much less rigid, causing a trampoline effect as people walk around the room. Incidentally, this may be why the ceiling of the Great Hall below has been replaced twice and repaired multiple times since the National Trust for Historic Preservation took ownership in 1974.

The Upper Drawing Room is very similar in plan and ornamentation to the room below it but remains closed in order to protect the delicate plaster in the first-floor Drawing Room.

Figure 65

Figure 66

Figure 67

ANOTHER SMALL PASSAGE leads into the southwest bedchamber. Because this room can only be accessed by way of spaces that are off limits for preservation reasons, it is not a part of the house tour. The firebox in this room has impressions in the mortar from delft tiles that once adorned it.

Figure 68

Figure 69

THE NORTHWEST BEDCHAMBER features little in the way of ornamentation save the firebox, which still bears the marks of its delft tiles. The spiral staircase is easily accessed in this room, and the installation of the lockable door within the staircase is described in Charles Drayton's diary in 1803.[14] Such a door would have been an added layer of protection against the theft of items such as Madeira that were stored in the attic.

The passageway providing access into the northeast corner of the second floor has enclosed shelves for storage and a window seat that lifts to reveal a hidden cavity below it. The former are referenced by Charles Drayton in 1806, as he used this space to store Madeira.[15]

14. *Drayton, Charles, diary, May 27, 1803.*
15. *Ibid., July 15, 1806.*

Figure 70

Figure 71

THE NORTHEAST BEDCHAMBER is the only room in the house that differs from its original floor plan. A T-shaped plaster partition on the east side of the room creates two smaller rooms within the larger one. Such a partition was likely due to the fact that Charles Drayton left two rooms in the house to his eldest daughter, Henrietta, following his death in 1820. Under her stewardship, she selected the northeast bedchamber and inserted the partition, and she is believed to have completed a similar modification in the Upper Great Hall, as partitions were created to convert one square room into two rectangular spaces, with a central hallway stretching from the Stair Hall landing to the portico door. These were constructed in the early nineteenth century, although the reason for their construction remains unknown. The mantel and overmantel in this room remain unchanged from their original appearance, but a Rumford firebox was installed, presumably when Charles Drayton had similar fireboxes installed on the first floor.

DRAYTON HALL

Figure 72

THE ATTIC IS A fascinating space that reveals many things about changes to the house over the years. Along the perimeter of the attic, most of the original timbers remain. They contain no nails, only mortise and tenon joints that hold them firmly together. Also visible are the scribe marks made by the carpenter to indicate which pieces fit together and where. Much like assembly instructions for modern furniture, these marks would be made as the timbers were cut and arranged on the ground and then used for reference as the structure was erected. Enough of the original framing survives in the attic to reveal the shape of the original treble roof, as well as the location of scuppers that once connected the internal gutters to the external downspouts.

Figure 73

THE RAISED BASEMENT is referred to as such because it is constructed at ground level rather than underground, as we traditionally think of basements. This was a utilitarian space with plain plaster ceilings and stucco walls to help reflect light in the dim rooms. The original floor in the basement was paved with brick or ceramic tile. A few ceramic tiles survive around the perimeter of the central space and measure approximately six by eleven inches and are about one inch thick. The current stone pavers were probably installed in the early to mid-nineteenth century. The large fireplace in the center of the room suggests that meals were prepared in the house, and a massive iron crane that survives in the Drayton Hall Architectural Fragment Collection once swung in and out of this fireplace to suspend heavy kettles over the fire. Four corner rooms open off the large central area. Two of these rooms have no fireplaces and were most likely used for food storage at one time. The two smaller rooms on the front of the house do have fireplaces and may have been work spaces or even dwelling spaces for domestic workers.

Figure 74

Figure 75

Figure 76

CHAPTER 5

PRESERVING AN AMERICAN TREASURE

Imagine that the fate of a centuries-old, one-of-a-kind historic landmark is in your hands. Nowhere else in the country can visitors explore a historic site as old and as historically significant as this one, and it's up to you to decide how to preserve this place and its stories for the future. The entire site is remarkably unchanged, with original features—clues about its past—waiting to be discovered around every corner, and every choice you make has the potential to erase these clues forever.

THESE ARE THE WEIGHTY THOUGHTS that eleven men and women turned over in their minds as they faced one another around a meeting table in June 1983. The resulting conversation charted the course for a groundbreaking approach to preservation that shapes all the work we do and has made Drayton Hall a leader among historic sites.

Figure 77

Figure 78

Figure 79

Figure 80

ON THE FACE OF IT, the preservation philosophy at Drayton Hall seems very straightforward: preserve the site as the National Trust for Historic Preservation received it from the Drayton family in 1974. That means that instead of seeing the house restored to one period, as is often done at house museums, visitors get to see what a house looks like after passing through seven generations of one family. Ornate plaster ceilings that survived hurricanes and earthquakes, handmade bricks bearing the fingerprints of the enslaved people who made them and graffiti scrawled on the walls by Confederate soldiers are just some of the layers of history that bring to mind all of the people and the dramas that have come and gone from the property.

A LESS OBVIOUS but very real implication of our preservation philosophy is the incredible effort that it takes to keep things more or less the same. Exterior mortar crumbles and has to be replaced. Plaster ceilings develop cracks that must be monitored and repaired. The inexorable crackling and peeling away of eighteenth- and nineteenth-century paint has to be prevented or at least slowed down as much as possible. Floors sag, the roof develops a leak, a pane of glass breaks. To ignore any one of these issues could lead to a cascade of new problems that would require the kind of aggressive restoration work that threatens the authentic, original building materials that make Drayton Hall so special. Thus, the Preservation Department at Drayton Hall is always hard at work making repairs, monitoring the conditions of the three extant historic buildings on site, planning for larger projects, researching new techniques or sharing new ideas with other preservation professionals.

Figure 81

So rare and so challenging is our preservation philosophy that professionals at historic sites around the world look to Drayton Hall for inspiration. This was at the forefront of everyone's minds in 2012, when structural engineer Craig Bennett presented the findings of a study that assessed the structural integrity of the house's iconic portico. He found serious issues that would not be resolved with our customary light touch. This was going to be a large undertaking, and one subject to great scrutiny. For this reason, project leaders decided to assemble an international team of architects, engineers, conservators and architectural historians to steer the project and ensure that every detail would be carefully considered by a multidisciplinary team of experts. The portico project was successfully completed in 2016 and was the topic of numerous newspaper articles, conference presentations and academic papers. Notable project details include:

Figure 82

- Giant steel collars enabled us to lift up the entire portico structure (forty thousand pounds) in place while removing concrete below. The two columns that were used to lift everything were raised up 1/125th of an inch (the height of two pieces of printer paper) and 1/50th of an inch (five pieces of printer paper) respectively;
- A discarded snack wrapper was found embedded in the concrete deck of the portico and enabled us to date early twentieth-century portico repairs to sometime between 1923 and 1941, when Nabisco used the logo printed on the wrapper;

Figure 83

- Three threaded steel rods are hidden within the portico to tie it securely to the building (two more are easier to spot in the open portico ceiling). Each rod has secret access points for staff to periodically tighten the nut on the rod. Those with keen eyes might spot two exposed locations in the basement where we can tighten the rods. They've been faux-painted to closely resemble the surrounding plaster.
- A fourth area may be opening up the ceiling on the first floor of the portico and seeing what it shows about its past—paint layers and so forth.

PRESERVATIONISTS REGULARLY visit to see how the work was completed before undertaking similar projects at other historic sites, and the extensive records from the project are included in the Drayton Hall Preservation Archive as reference materials for future stewards of Drayton Hall.

Figure 84

NOT LONG AFTER the last of the construction debris was cleared away from the portico project, Drayton Hall embarked on a new preservation project, this time to address structural issues in the Great Hall—the first and one of the most impressive rooms visitors see when they tour the main house. Two massive timbers, called summer beams, are essential components of a system of heavy wood timbers that support this large central room. These two summer beams, the only ones that survive in the house, were found to be badly damaged by termites and thus not sufficient to safely and reliably support the weight of a room full of people. The engineer presented two possible solutions: keep the historic summer beams and support them with steel columns from below, or replace them with new materials. Can you guess which option was selected?

Visitors to Drayton Hall have likely seen the three black pipe columns that support the Great Hall from the basement. This course of action made the Great Hall structurally sound. It preserved original framing materials, and it's completely reversible. What you can't see is all the work that was done beneath the floor that makes these supports so effective. It's a crucial detail that Drayton Hall's archaeologist knows better than anyone and a good example of the multi-disciplinary approach to preservation that makes this site so special.

Figure 85

The Preservation Department at Drayton Hall is composed of professionals from several disciplines, including architecture, archaeology, landscape and horticulture. Almost every preservation project undertaken here requires collaboration across disciplines, and getting columns in place to support the summer beams was no exception. Before any pipe columns could be erected, their locations were carefully mapped out on the basement floor, the stone pavers were removed and then Drayton Hall's archaeologist carefully excavated three large cubes of earth measuring four feet on each side. Such work often has to be done before building or landscape projects at Drayton Hall to identify hidden features and remove cultural materials that might be disturbed in the course of a project. The resulting spaces from this excavation were fitted with a steel framework that anchors the columns and then filled with a material that is stiff enough to hold the steel in place but soft enough to be shoveled out by hand, if necessary. The old stone pavers were modified to fit securely around the new pipe columns, and with that, all evidence of the archaeological excavation and the giant footers disappeared beneath the floor.

MANY PRESERVATION PROJECTS at Drayton Hall resemble the installation of the pipe columns in that they involve a multidisciplinary team working behind the scenes to accomplish challenging tasks. The staff frequently ventures into uncharted territory to develop innovative solutions that protect Drayton Hall's extraordinary historical resources in ways that don't attract much attention. It's a delicate balancing act to make sure the historic paint stays on the wall without distracting visitors with efforts to keep it there.

CONCLUSION

Drayton Hall is one of the few remaining witnesses to events that shaped the South Carolina Lowcountry and, indeed, the United States as a whole. The estate is perhaps the most authentic and well-preserved survivor of southern colonial life that can claim an unbroken bond to its very beginning. Held by a single family for more than 235 years, the site is a survivor of the American Revolution, the Civil War, natural disasters and the unrelenting pressures of modernity. Today, Drayton Hall lives on as an architectural treasure and an active archaeological site, complete with an extensive museum collection of rare eighteenth- and nineteenth-century objects and artifacts. Its power to educate, enlighten and inspire is an unlikely gift from the past.

A rare survivor, Drayton Hall passed through seven generations of family ownership before being transferred to the National Trust for Historic Preservation in 1974. Today, the site is a National Historic Landmark operated by the Drayton Hall Preservation Trust. It is unique for its leading-edge architectural design but equally for its level of preservation. Despite wars, natural disasters, economic hardships and three centuries of ownership, the house is remarkably intact, as it was never altered with the addition of electricity, plumbing, heating or air conditioning. Because of its rare state of survival, the site serves as a timeline and a time capsule showing both change and continuity through three centuries of American history.

Drayton Hall's rare state of preservation affords a rare and undisturbed look at the past through archaeology, architectural research and documentary investigations. Such multidisciplinary work is central to our understanding of the estate and the individuals who lived and worked there. Importantly, our research is constantly expanding through new discoveries, acquisitions and findings. Just as Drayton Hall

CONCLUSION

was not a static place during its past, it is a dynamic site today that is constantly evolving given our investment in research and scholarship. We, as stewards of the past, strive to better understand our shared American past to better understand our shared American future.

LIST OF FIGURES

1. Contemporary view of Drayton Hall Drawing Room. The ceiling in this room is the only complete hand-carved ceiling to survive from colonial America. *Photograph by Willie Graham.*
2. Drayton Hall elevation drawing, attributed to John Drayton (1715–1779), circa 1740. *Drayton Hall Museum Collection (NT 2013.1.1), courtesy of Drayton Hall, a historic site of the National Trust for Historic Preservation, gift of Historic Charleston Foundation at the request of Mr. Charles H. Drayton III. Photograph courtesy of the Colonial Williamsburg Foundation.*
3. Curator of Historic Architectural Resources Patricia Lowe Smith working on drawing room overmantel. *Photograph by Leslie McKellar.*
4. List of books found in the papers of Charles Drayton (1743–1820) thought to belong to his father, John Drayton (1715–1779). This particular page displays a list of architectural pattern books that likely influenced Drayton's design of his home seat. *Drayton Papers Collection (NT 91.24), courtesy of Drayton Hall, a historic site of the National Trust for Historic Preservation, gift of Mr. Charles H. Drayton III.*
5a. Signature page from arithmetic book belonging to John Drayton (1715–1779), 1733. *Drayton Papers Collection (NT 91.24), courtesy of Drayton Hall, a historic site of the National Trust for Historic Preservation, gift of Mr. Charles H. Drayton III.*
5b. Sample page from arithmetic book belonging to John Drayton (1715–1779), 1733. *Drayton Papers Collection (NT 91.24), courtesy of Drayton Hall, a historic site of the National Trust for Historic Preservation, gift of Mr. Charles H. Drayton III.*
6. Miniature of Charles Drayton (1743–1820), date and artist unknown. *Drayton Hall Museum Collection (NT 2008.4.2), courtesy of Drayton Hall, a historic site of the National Trust for Historic Preservation, gift of Mr. Charles H. Drayton III. Photograph by Russell Buskirk.*

LIST OF FIGURES

7. Engraving of William Henry Drayton after portrait by Pierre Eugene du Simitiere (1736–1784), circa 1783. *Courtesy of the New York Public Library.*

8. Drayton Hall's original columns from the first floor of the portico. Removed in the early nineteenth century as part of repair efforts following the American Revolution, these limestone columns have sat in the basement of Drayton Hall since at least 1875. *Photograph by Willie Graham.*

9. Late eighteenth-century mirror knob with image of William Henry Drayton (1742–1779). Copper alloy, enamel and iron. *Drayton Hall Museum Collection (NT 81.4), courtesy of Drayton Hall, a historic site of the National Trust for Historic Preservation, gift of Mr. John Mayer. Photograph by Russell Buskirk.*

10. Excerpt from Charles Drayton's (1743–1820) diary. This entry illustrates how Drayton visited with former classmate and contemporary scholar Alexander Kuhn in Philadelphia on August 7, 1806. *Drayton Papers Collection (NT 91.24), courtesy of Drayton Hall, a historic site of the National Trust for Historic Preservation, gift of Mr. Charles H. Drayton III.*

11. Slave housing plan. While housing is not depicted, it likely corresponds with the presence of "Negro Gardens" and "Negro House Yards." *Drayton Papers Collections (NT 91.24), courtesy of Drayton Hall, a historic site of the National Trust for Historic Preservation, gift of Mr. Charles H. Drayton III.*

12. *Left*: 1765 watercolor painting of Drayton Hall S.C. by Pierre Eugene du Simitiere (1736–1784). Courtesy of J. Lockard. *Right*: circa 1845 drawing of Drayton Hall by Lewis Reeve Gibbes (1810–1894). *Drayton Papers Collection (NT 91.24), courtesy of Drayton Hall, a historic site of the National Trust for Historic Preservation, gift of Mr. Charles H. Drayton III.*

13a. Excerpt from Charles Drayton's (1743–1820) diary, May 1, 1817. *Drayton Papers Collection (NT 91.24), courtesy of Drayton Hall, a historic site of the National Trust for Historic Preservation, gift of Mr. Charles H. Drayton III.*

13b. Excerpt from Charles Drayton's (1743–1820) diary, January 20, 1820. *Drayton Papers Collection (NT 91.24), courtesy of Drayton Hall, a historic site of the National Trust for Historic Preservation, gift of Mr. Charles H. Drayton III.*

13c. Excerpt from Charles Drayton's (1743–1820) diary, September 3, 1792. *Drayton Papers Collection (NT 91.24), courtesy of Drayton Hall, a historic site of the National Trust for Historic Preservation, gift of Mr. Charles H. Drayton III.*

14. Circa 1791 map of the Drayton Hall property attributed to Charles Drayton (1743–1820) showing field locations and names. *Drayton Papers Collection (NT 91.24), courtesy of Drayton Hall, a historic site of the National Trust for Historic Preservation, gift of Mr. Charles H. Drayton III.*

15. Post–Civil War photograph of John Drayton (1831–1912). *Courtesy of Drayton Hall, a historic site of the National Trust for Historic Preservation.*

LIST OF FIGURES

16. Mid- to late nineteenth-century embossed leather traveling trunk with brass mounts and riveted sole belonging to either John Drayton (1831–1912) or James Drayton (1820–1867). *Drayton Hall Preservation Trust Decorative Arts Collection (DHPT 2015.2), courtesy of the Drayton Hall Preservation Trust.*

17a. Photograph of phosphate mining at Drayton Hall. *Courtesy of Drayton Hall, a historic site of the National Trust for Historic Preservation.*

17b. Photograph of phosphate mining at Drayton Hall. *Courtesy of Drayton Hall, a historic site of the National Trust for Historic Preservation.*

18. Photograph of privy with chimney by Frances Benjamin Johnston, circa 1930s. Constructed in 1791 for Charles Drayton, this structure was converted into an office during the phosphate mining period. *Courtesy of the Library of Congress Prints and Photographs Division.*

19. Photograph of Harriet Mayes, Richmond Bowens Jr. and Anna Bowens. *Courtesy of Drayton Hall, a historic site of the National Trust for Historic Preservation.*

20a. Circa 1875 stereoview card of Drayton Hall, published by G.N. Barnard, No. 263 King Street, Charleston, S.C. of the South Carolina Views series. Photographed after a period of decline, this image shows the house in the midst of badly needed repairs. *Drayton Hall Museum Collection (NT 2016.1.1), courtesy of Drayton Hall, a historic site of the National Trust for Historic Preservation, gift of Mr. and Mrs. Paul and Dale Marion.*

20b. 1916 photograph of Drayton Hall showing the reflecting pond and ornamental garden mound. *Courtesy of Drayton Hall, a historic site of the National Trust for Historic Preservation.*

21. Turn-of-the-twentieth-century photograph showing members of the Drayton family in the garden. *Courtesy of Drayton Hall, a historic site of the National Trust for Historic Preservation.*

22. Mid-twentieth-century photograph showing the original location of the Caretaker's House. *Courtesy of private Drayton family collection.*

23. Property advertisement from the *South Carolina Gazette*, December 15, 1737. This publication importantly describes the plantation complex that existed on site prior to John Drayton's 1738 purchase.

24. Collection of iron tools from the Drayton Hall Archaeological Collection. *Courtesy of Drayton Hall, a historic site of the National Trust for Historic Preservation.*

25a. Flemish bond brickwork on the eastern façade of Drayton Hall. *Photograph by Willie Graham.*

25b. Transom window and associated brickwork. The delicate glass window transom draws attention to the space, and this is reinforced by the rubbed and gauged brickwork found around the door opening. *Photograph by Willie Graham.*

26. Detail of portico metal railings and their terminus in masonry of main house. The metal railings are believed to have been imported from England, although some of their fabrication may have taken place on site. *Photograph by Willie Graham.*

LIST OF FIGURES

27a. A sample of four Delft tiles, England, circa 1750. *Drayton Hall Museum Collection (NT 80.24.1.1-48), courtesy of Drayton Hall, a historic site of the National Trust for Historic Preservation, gift of Mr. Charles H. Drayton II and Mrs. Martha Drayton Mood. Photograph courtesy of the Colonial Williamsburg Foundation.*

27b. A sample of tin-glazed earthenware tiles from the Drayton Hall Archaeology Collection, England and the Netherlands, circa 1750. *Courtesy of Drayton Hall, a historic site of the National Trust for Historic Preservation.*

28. Limestone column base from the Drayton Hall Architectural Fragment Collection. *Courtesy of Drayton Hall, a historic site of the National Trust for Historic Preservation. Photograph courtesy of the Colonial Williamsburg Foundation.*

29. Mahogany stair bracket from the Drayton Hall Stair Hall. *Drayton Hall Architectural Fragment Collection, courtesy of Drayton Hall, a historic site of the National Trust for Historic Preservation. Photograph courtesy of the Colonial Williamsburg Foundation.*

30. Circa 1790 map of the Drayton Hall property attributed to Charles Drayton (1743–1820) with modern colorization to illustrate water features. *Drayton Papers Collection (NT 91.24), courtesy of Drayton Hall, a historic site of the National Trust for Historic Preservation, gift of Mr. Charles H. Drayton III.*

31. 1765 watercolor painting of Drayton Hall S.C. by Pierre Eugene du Simitiere (1736–1784). *Courtesy of J. Lockard.*

32a. Circa 1845 drawing of the Drayton Hall Garden House by Lewis Reeve Gibbes (1810–1894). Constructed in 1747 and marked with this date above the primary entrance door, this building fulfilled a variety of social and entertaining functions until it was systematically dismantled in 1870. *Drayton Papers Collection (NT 91.24), courtesy of Drayton Hall, a historic site of the National Trust for Historic Preservation, gift of Mr. Charles H. Drayton III.*

32b. Model of Drayton Hall Garden House by Timothy Richards shown at its original location. *Courtesy of Drayton Hall, a historic site of the National Trust for Historic Preservation.*

33a. Oak trees on the Drayton Hall grounds. *Photograph by Robbin Knight.*

33b. Oak trees on the Drayton Hall grounds. *Photograph by Robbin Knight.*

34. Detail of Drayton Hall's Stair Hall. *Photograph by Willie Graham.*

35. Drayton Hall elevation drawing, attributed to John Drayton (1715–1779), circa 1740. *Drayton Hall Museum Collection (NT 2013.1.1), courtesy of Drayton Hall, a historic site of the National Trust for Historic Preservation, gift of Historic Charleston Foundation at the request of Mr. Charles H. Drayton III. Photograph courtesy of the Colonial Williamsburg Foundation.*

36. Model of Drayton Hall showing W-shaped roof. *Courtesy of Drayton Hall, a historic site of the National Trust for Historic Preservation.*

37. Plate 64 of William Kent's *The Designs of Inigo Jones*, 1767. *Courtesy of the Digital Library for the Decorative Arts and Material Culture.*

LIST OF FIGURES

38. Great Hall chimneypiece. *Photograph by Catherine Ann Photography.*
39. Drayton Hall's iconic portico. *Photograph by Leslie McKellar.*
40. View of the portico columns. *Photograph by Willie Graham.*
41. Checkerboard pattern on the first floor of the portico. *Photograph by Corey Heyward.*
42. Circa 1845 drawing of the Drayton Hall Great Hall ceiling by Lewis Reeve Gibbes (1810–1894). *Drayton Papers Collection (NT 91.24), courtesy of Drayton Hall, a historic site of the National Trust for Historic Preservation, gift of Mr. Charles H. Drayton III.*
43. Existing ceiling medallion in Great Hall. *Photograph by Leslie McKellar.*
44. Great Hall. *Photograph by Catherine Ann Photography.*
45. Detail of triglyphs and metopes in Great Hall. *Photograph by Willie Graham.*
46. Drawing Room. *Photograph by Corey Heyward.*
47. Drawing Room ceiling. *Photograph by Willie Graham.*
48. Detail of capital in Drawing Room. *Photograph by Willie Graham.*
49. Mid-twentieth-century view of the Drawing Room. *Courtesy of Drayton Hall, a historic site of the National Trust for Historic Preservation.*
50. Detail of Drawing Room mantel. *Photograph by Willie Graham.*
51. Detail of mahogany swag in Drawing Room. *Photograph by Leslie McKellar.*
52. Growth Chart Room. *Courtesy of the Drayton Hall Preservation Trust.*
53. Growth Chart Room. *Photograph by Corey Heyward.*
54. Detail of growth chart. *Photograph by John Apsey.*
55. Service staircase. *Photograph by John Apsey.*
56a. Library. *Courtesy of the Drayton Hall Preservation Trust.*
56b. Architectural print of mantel, plate 84 by Batty Langley, circa 1770 print after his 1739 drawing. The image is based on the 1728 drawing by James Gibbs. *Drayton Hall Preservation Trust Decorative Arts Collection (DHPT 2017.3).*
57. Detail of sham door and glazed headers in Dining Room. *Photograph by Willie Graham.*
58. Dining Room. *Photograph by Corey Heyward.*
59. Detail of compo mantel in Dining Room. *Photograph by Willie Graham.*
60. Stair Hall. *Photograph by Willie Graham.*
61. Soffit below second-floor landing in Stair Hall. *Photograph by Catherine Ann Photography.*
62. Detail of stair brackets and balusters in Stair Hall. *Photograph by Catherine Ann Photography.*
63. Upper Great Hall. *Photograph by Willie Graham.*
64. Detail of overmantel in Upper Great Hall. *Courtesy of the Drayton Hall Preservation Trust.*
65. Preservation work in Upper Great Hall. *Courtesy of Drayton Hall, a historic site of the National Trust for Historic Preservation.*

LIST OF FIGURES

66. Preservation work on ceiling of Great Hall. *Courtesy of Drayton Hall, a historic site of the National Trust for Historic Preservation.*
67. Upper Drawing Room. *Photograph by Leslie McKellar.*
68. Southwest Bedchamber. *Photograph by Corey Heyward.*
69. Northwest Bedchamber. *Courtesy of the Drayton Hall Preservation Trust.*
70. Detail of delft ghosts in Northwest Bedchamber firebox. *Courtesy of the Drayton Hall Preservation Trust.*
71. Northeast Bedchamber. *Courtesy of the Drayton Hall Preservation Trust.*
72. Partition creating smaller room on east side of Northeast Bedchamber. *Courtesy of the Drayton Hall Preservation Trust.*
73. Attic. *Courtesy of Drayton Hall, a historic site of the National Trust for Historic Preservation.*
74. Basement. *Photograph by Corey Heyward.*
75. Basement fireplace. *Courtesy of Drayton Hall, a historic site of the National Trust for Historic Preservation.*
76. Paintwork in Drayton Hall. *Photograph by Willie Graham.*
77. Drayton Hall and its grounds. *Photograph by Leslie McKellar.*
78. 1970s photograph of Drayton Hall's eastern façade. *Courtesy of the Library of Congress Prints and Photographs Division.*
79. Present-day photograph of Drayton Hall's eastern façade. *Courtesy of the Drayton Hall Preservation Trust.*
80. Graffiti in Drayton Hall. *Courtesy of the Drayton Hall Preservation Trust.*
81. Assistant Curator of Historic Architectural Resources Cameron Moon working in Drawing Room. *Courtesy of the Drayton Hall Preservation Trust.*
82. Giant steel collars lifting portico. *Courtesy of Drayton Hall, a historic site of the National Trust for Historic Preservation.*
83. Nabisco wrapper found embedded in the concrete deck of the portico. *Courtesy of the Drayton Hall Preservation Trust.*
84. Steel columns supporting summer beams in basement. *Courtesy of the Drayton Hall Preservation Trust.*
85. Archaeology in the basement. *Courtesy of the Drayton Hall Preservation Trust.*